W9-BUN-477

super-cute
CHIBIS
to draw and paint

super-cute CHIBIS

to draw and paint

Joanna Zhou

BARRON'S

A QUARTO BOOK

First edition for North America
published in 2011 by Barron's
Educational Series, Inc.

Copyright © 2011 Quarto Inc.

All rights reserved. No part
of this publication may be
reproduced or distributed in any
form or by any means without
the written permission of the
copyright owner.

All inquiries should
be addressed to:
Barron's Educational Series, Inc.
250 Wireless Boulevard
Hauppauge, NY 11788
www.barronseduc.com

ISBN: 978-0-7641-4677-0
Library of Congress Control
Number: 2011923185

QUAR.CCDP

Conceived, designed, and
produced by Quarto
Publishing plc
The Old Brewery
6 Blundell Street
London N7 9BH

Senior editor: Ruth Patrick
Art editor: Emma Clayton
Designer: Karin Skånberg
Art director: Caroline Guest
Copy editor: Ruth Patrick
Proofreader: Sally MacEachern
Indexer: Helen Snaith
Picture researcher: Sarah Bell

Creative director: Moira Clinch
Publisher: Paul Carslake

Color separation in China by
Pica International Pte Ltd
Printed in Singapore by Star
Standard International Pte Ltd

10 9 8 7 6 5 4 3 2 1

CONTENTS

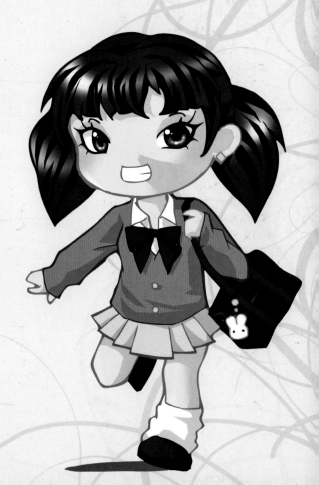

FOREWORD

Chibi style has always been my favorite part of manga because it's cute, fun, and easy to draw. Ten years ago, I couldn't find a readily available chibi-drawing tutorial so I decided to create a simple one of my own and post it online. I was really pleased when I received feedback from people who found it useful, and realized that spreading enthusiasm for drawing manga was what I loved doing.

Sharing my artwork online, receiving feedback, and getting to know other artists was a huge factor in perpetuating my love for manga art. I struggled for many years trying to "validate" manga style as part of my academic studies and the core identity of myself as an artist and designer. You may very well encounter similar obstacles at your school or university, but remember that passion for a subject will eventually triumph over everything else.

When I was asked to write this book, it felt like the most amazing opportunity to put everything I've learned along the way into one carefully thought-out volume. I hope you'll find this resource inspiring, instructional, and above all, good fun to keep you motivated. Good luck and happy drawing!

Joanna Zhou

The first chapter examines traditional and digital art techniques and principles, ensuring you have the background to get started. The Chibi Showcase (pages 42–103) features step-by-step instructions to help you create a wide variety of fun chibi characters. Chibis in Concept details the use of chibis in the professional world, and Promoting Your Work discusses ways of presenting your work, and ultimately, getting published.

ABOUT THIS BOOK

Color palettes
Color palettes are featured, showing the main color, and highlight and shadow tones for each element of the illustration.

Art instruction
Art techniques are detailed in clear, step-by-step format with key stages illustrated and digital menus shown where relevant.

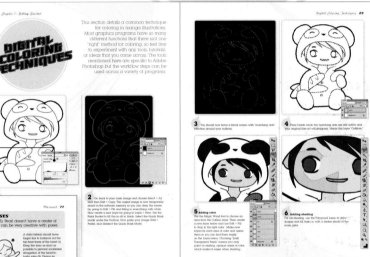

Poses and expressions
Each chibi features alternative poses and expressions, designed to reflect his or her character.

Demonstrations
Easy-to-follow visual demonstrations are featured, showing work in various stages.

Step-by-step instructions
Each stage of the illustration is detailed with clear text and images, from sketch stage to final coloring.

Examples of work
Professional examples of work are shown and critiqued, to demonstrate what works and what doesn't.

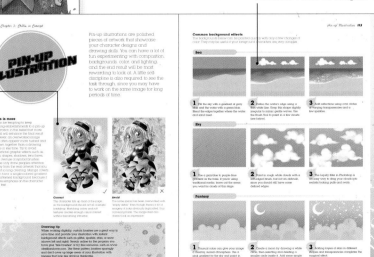

Creative concepts
Design ideas support each topic and provide inspiration.

INTRODUCING CHIBIS

Easy to draw and super cute, chibis are the ever-popular ambassadors of manga art. Also known as SD or "super-deformed" style, chibi characters are easily recognized through their distinctive large heads, small bodies, and exaggerated facial features.

Chibis originated in manga comics and have influenced other genres such as anime, video games, and toys. Despite their childlike appearance, chibis are usually representations of adult characters and are used metaphorically to express emotion, stylization, or a slapstick situation.

In this book you will learn how to draw a wide range of human

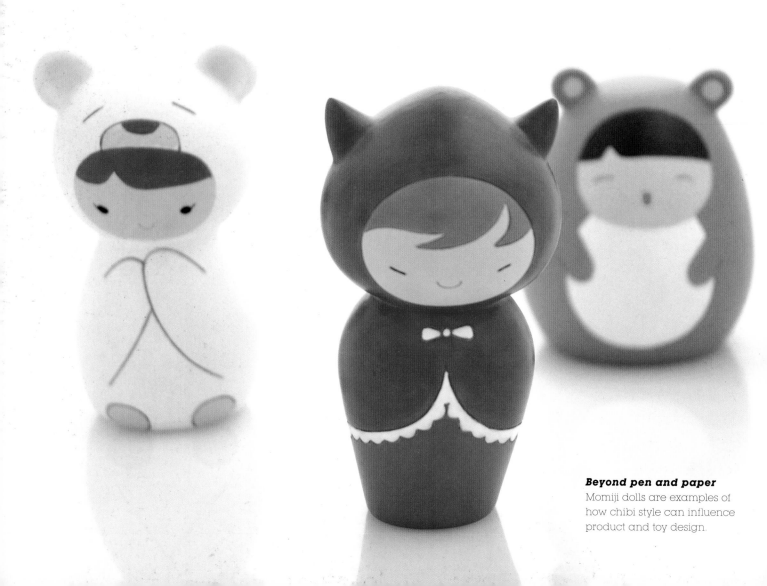

Beyond pen and paper
Momiji dolls are examples of how chibi style can influence product and toy design.

and animal chibis, all guided by the underlying theory of Japanese cuteness, or "kawaii." Discover how to "chibify" fictional characters, celebrities, friends, family, or pets.

The additional advantage of chibi style is that it's perfectly suited to beginner artists, since you are working with simplified proportions. This gives you an understanding of emotion, movement, and character design without being restricted by the need for advanced technical skills. Chibi style comes in bite-sized learning curves and you can see your own progress much faster!

Attitude is just as important as technique when it comes to loving art and staying motivated. Remember to enjoy the process of drawing rather than aiming for a perfect final piece. To create happy associations, draw at a time when you're relaxed and inspired, listening to your favorite music, and you won't be interrupted for at least an hour or two. Draw on the weekends, and during holidays—make it a special activity that becomes your reward and an escape from daily life.

Chibis in manga
Simple characters with exaggerated expressions are perfect for storytelling.

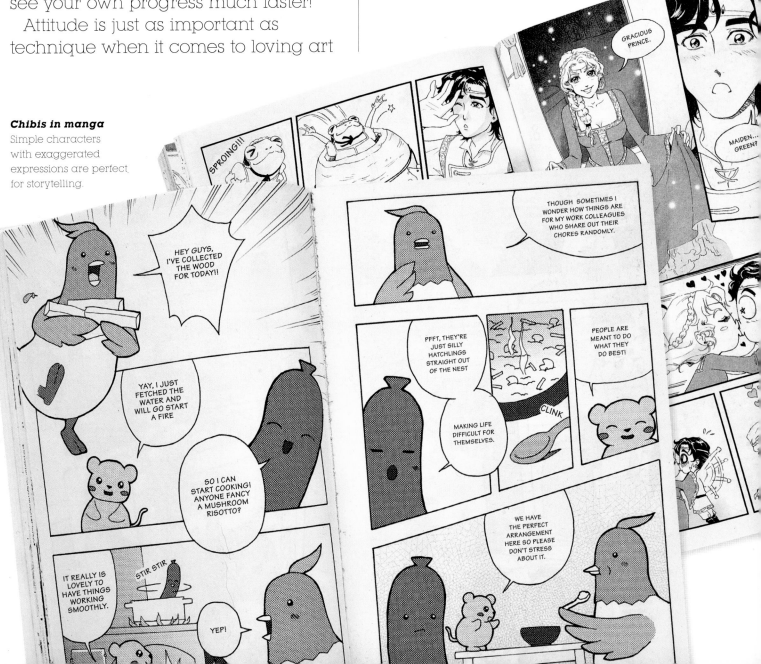

Chapter One

GETTING STARTED

This chapter features everything you need to know about art equipment and chibi drawing techniques. It will teach you the visual theory behind cute manga style, help you choose the right drawing material, and show you how to create professional-looking finished artwork using traditional or digital media.

INKING TECHNIQUES

Being able to turn your sketch into black line-art is an integral part of comic creation. This takes some confidence and a steady hand. It's a very enjoyable process though, since you are essentially tracing over contours you've already drawn. This familiarity makes the task quite therapeutic and a perfect way to relax and unwind.

Inking effects

There are many different methods of inking an image to make it more exciting, such as using different line widths to give the image more depth and variation or adapting your style to suit the subject matter of your image.

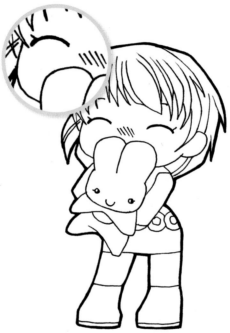

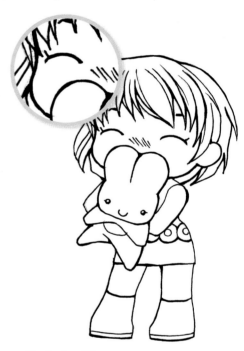

Single outline

This is the fastest method. Simply go over your outlines once using a thin fineliner (0.05 mm, 0.1 mm).

Thicker outline

A quick and easy way to create some line variation is to go over the outer edge of your character with a thicker fineliner (0.3 mm, 0.5 mm).

Varied outlines

This effect is achieved by going over the same area several times and naturally thickening it where two lines intersect.

Fineliners

- **Pros:** Technical drawing pens that come in a variety of thicknesses: 0.05 mm, 0.1 mm, and 0.3 mm. They are convenient, portable, and widely available. Some brands are waterproof.
- **Cons:** Inflexible nibs make it trickier to get a good line variation. The pigmentation isn't as high as ink, so your line-art may not scan as solid black and may require a digital clean up.

Nib ink pens

- **Pros:** These have interchangeable nibs that are dipped in ink and are very cost effective. Almost all Japanese mangas are inked in this way so you can achieve a very authentic effect.
- **Cons:** Nib pens are time-consuming to draw with, fussy to clean, and come with a higher risk of ink drips or spillage. They also function poorly on some paper surfaces so you may need to buy special smooth manga paper.

LIVE TRACING

The program Adobe Illustrator has a "Livetrace" function that lets you clean up a hand-inked image into crisp solid lines suitable for digital rendering. This is not a mandatory step but is recommended if you have access to Illustrator.

1 Scan and save your line-art as a 300dpi jpg. Open a new document in Illustrator and click on File and then Place your image. Open the "Tracing Options" menu next to the "Livetrace" button at the top. Make sure that the "Ignore White" box is checked. (You only need to change this setting once, and in future you can simply use the Livetrace button.)

2 Click "Livetrace" and the program will smooth out your outlines. This might take a minute or two. After livetracing has finished, click "Expand."

3 Now your outlines are pure black, you can copy and paste them into a Photoshop file for future digital coloring.

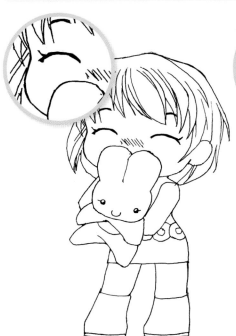

Nib pen outlines
Using the thinnest nib pen, known as the Maru nib, you can create very fine lines and hatching. By altering the pressure on other nibs, you can also alter line width.

Freehand digital outlines
These are drawn using a pressure-sensitive graphics tablet with a hard-edged brush. For best results, zoom in until you can see the pixels and work at that size.

Vector digital outlines
These are lines drawn using the Line Tool or Bezier Curve in Adobe Illustrator. This can be done with a mouse and will give your image a contemporary, digital feel.

Digital inking
■ **Pros:** Working on the computer lets you zoom into the image and create super-crisp lines and it's easier to correct mistakes. Does not require any scanning if you plan to color digitally.
■ **Cons:** Requires a lot of hardware and software to get started. Not recommended as a starter technique; most artists learn how to ink by hand first and then try out digital.

Gel ink pens/Ball-point pens
■ **Pros:** These are cheap and easy to come by. Good for sketching or doodling.
■ **Cons:** Not recommended for serious inking work. Both have a tendency to smear, are not waterproof, and the line width is usually too thick for manga illustration.

CHOOSING MEDIA

After you've outlined your chibi, it's time to color it in. The same image can appear nostalgic, romantic, edgy, or fashionable depending on which media you choose. Here is an overview of popular manga coloring techniques.

- **Pros:** Traditional media is cheaper, convenient, and easily accessible for beginners. Many artists feel that drawing or painting naturally is more soothing than staring at a computer screen, and you get a very tactile experience of creating art. The final piece is more personal and ideal for gifts or wall art.

- **Cons:** You need a lot of space and equipment to work effectively. Mistakes are hard to correct and you only get one chance to choose the right colors. You only have one copy of the original so it's difficult to make replicas, exacerbated by the fact that some traditional media don't scan well.

TRADITIONAL MEDIA

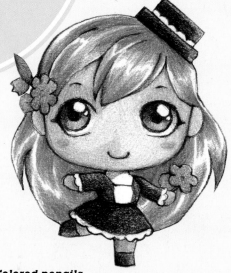

Colored pencils
Convenient and affordable, colored pencils work well on most types of paper. The key to getting a vibrant finish is to layer similar shades on top of each other so you have a bright, opaque finish.

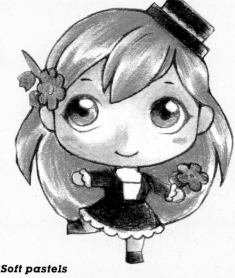

Soft pastels
These have vivid pigmentation but are challenging to use when creating small details. An easy shading technique is to apply two colors and blend them together with your fingertips or a cotton swab.

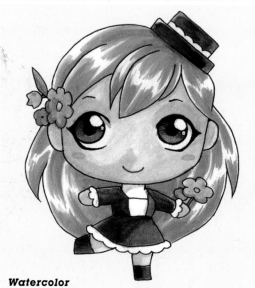

Watercolor
"Half-pan" paints are most convenient to use. As shown above, you can also try painting your chibi in watercolor, then using colored pencil on top. This gives you better blending control.

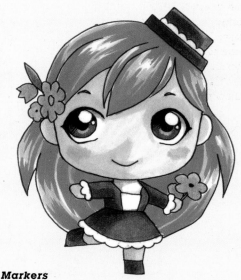

Markers
Not to be confused with regular felt-tip markers, alcohol-based markers are very popular in Japanese manga illustration. These give vivid, smooth color.

Traditional media is any color that you apply by hand directly onto your image. Most people start off using traditional media and, chances are, you will already have some art supplies at home. These can be divided into "wet" media, such as watercolor or markers, and "dry" media, such as colored pencils or pastels.

Digital media includes any method of coloring or creating an image from scratch on the computer. Digital art is more commercially viable because it looks slick in print, and is worth trying out if you're thinking of drawing professionally someday.

See also

Traditional coloring techniques page 18
Digital coloring techniques page 22

DIGITAL MEDIA

■ **Pros:** Digital drawing software gives you an extremely flexible range of visual effects and sleek-looking final artwork. Mistakes can be precisely corrected and it's very easy to adjust colors, textures, patterns, and text. Digital equipment is portable and you can work from any location.

■ **Cons:** Initial set-up costs are high and you may need upgrades to your hardware or software over the years. Some artists feel digital art is less personal, since you don't have an original piece of work to keep. Digital art can be harder to learn, since you're getting familiar with new technology and drawing theory at the same time.

Cel-shading

This type of coloring mimics the style used in animation cel sheets. It has clearly defined outlines with solid blocks of color. Many artists like to use a combination of cel- and smooth shading for an appealing illustrative effect.

Soft shading

This is done using soft paint or airbrushes in a graphics program. This technique is only possible with a pressure-sensitive graphics tablet that lets you blend colors smoothly.

Vector art

This technique is relatively rare in manga style. Instead of working with lines and shading, single-colored vector shapes are layered to create a contemporary effect with no outlines.

Digital screentone

Commonly seen in manga comics, screentone is a pattern of black-and-white dots that emulates shades of gray.

Experimentation and practice is the key to learning traditional media. Every time you need to buy new equipment, try out something from a different brand. Paper, pencils, erasers, or paints can differ substantially and it's about testing everything out to see what combination works best for you. Here are some tips to make sure you get the best out of your art supplies.

Color palettes

When working traditionally, you need to understand how different hues blend with each other. Blue, yellow, and red are primary colors, meaning you cannot create these using other shades. However, by mixing those together, you can create the secondary shades of green, purple, and orange. You can also add white or use light washes to create pastel shades such as pink or lilac. Pastel colors are frequently seen in chibi style because they appear soft and cute. See page 39 for more information on creating kawaii palettes.

Traditional media relies on either mixing or layering pigments together. When working with paint or watercolor, using titanium white to bind colors together makes them more opaque and pastel than if you just mixed the primary and secondary hues alone.

Complementary colors can be used strategically positioned next to one another for finishing touches because they automatically pop out. When mixed together, they create a neutral gray.

If you're working with dry media such as colored pencil or pastel, layer several analogous colors on top of each other to make the shading and highlights more vibrant.

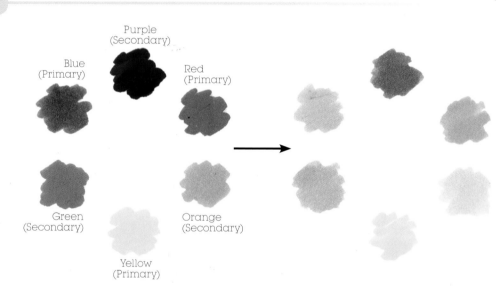

Primary and secondary color palette

Blue (Primary)
Purple (Secondary)
Red (Primary)
Green (Secondary)
Yellow (Primary)
Orange (Secondary)

Pastel color palette

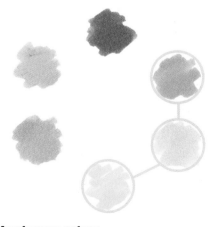

Complementary colors

Colors that sit opposite each other on the color wheel have the greatest contrast. These can be used liberally for vivid palettes or strategically to add color accents to an otherwise muted image.

Analogous colors

Colors that sit next to each other on the color wheel are useful for choosing shadow and highlight tones; for instance, an orange object can have a yellow-tinted highlight with a red-tinted shadow.

Tonal contrasts

Tone refers to the lightness or darkness of a color. For instance, a single color such as red can vary in tone from rusty brown to a baby pink. You'll discover from the color palettes in The Chibi Showcase (see page 42) that some complex illustrations actually have very simple color schemes, and rely on tonal variation to create interest. Tone is also associated with emotional connotations. Darker colors seem sinister, bright colors feel upbeat, and pastel colors appear cute and gentle. Pastel tones can be freely mixed together as they're very soft, but other tonal palettes should be carefully chosen to prevent color clashes.

Black-and-white manga illustration is a classic example of working with tonal contrast, as everything must be depicted in shades of gray. Drawing monochrome images is a valuable exercise in being able to see and use tone. Some artists mistakenly believe that by drawing too many comic pages they may "forget" how to work in color. If anything, the opposite is true, since working in black and white gives you a heightened sense of shading that translates to all your color work as well.

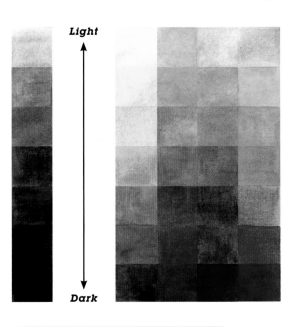

Light

Dark

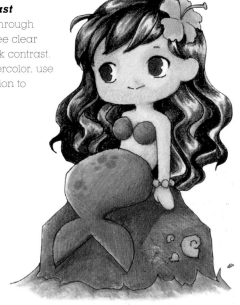

Working with contrast
If you view this chibi through squinted eyes, you'll see clear areas of light and dark contrast. When working in watercolor, use different levels of dilution to create lighter tones.

Breaking down the palette
Notice how every horizontal row of color in the same tonal value looks similar. This is why an image can appear washed out even if many different colors of the same tone were used. Make sure you experiment with shades from both ends of the scale.

Other considerations

Space
When drawing or coloring by hand, the larger the paper the easier the process will be. This also gives you more space to work in details and enhances the overall quality of your final image. Make sure your desk is clear of clutter and big enough to handle the paper and materials.

Light-box
Sometimes you may find it necessary to trace certain areas of a drawing. This can be used to ensure symmetry, clean up a sketch, or, in worse cases, salvage the best parts of the image to start over. For a cheap, makeshift alternative to a light-box, try clipping your pages together and tracing through a window during the day. Or you can scan your original image, heighten the contrast using digital software, and trace it from your computer's monitor screen with the brightness turned to maximum.

Painting tips
Cut off the top of a water bottle for a cheap and reusable water pot. When painting, always have some tissues or kitchen towels at hand to dab off the brush or absorb extra water on the image. Clean your brushes thoroughly afterward and let them dry on a flat surface.

Correcting mistakes
When inking, you can use correction fluid to fix minor mistakes. However, be wary that many traditional media don't stick well on dried correction fluid, so you may end up with patches. A strong pencil eraser can be used to fix mistakes in colored pencil, and extra water can be used to dilute watercolor. However, be careful not to overcorrect mistakes because this damages the paper surface and any pigment applied afterward will be unpredictable to work with.

Shading and highlights
Avoid using pure black to create shading. The pigments will quickly overwhelm your image and make it look dark and muddy. Instead, layer brown or ocher tones until you have the desired shadow. In contrast, pure white is often too bland to shade on because it's the same tone as the paper. The solution is to give all your white areas a slight tint, such as very pale blue, pink, or beige. This creates a much better starting point to choose matching shadow colors.

Translucency
A lot of traditional media shading is based on the concept of translucency. Colors are layered on top of each other to achieve a desired hue or tone.

TRADITIONAL COLORING TECHNIQUES

These steps show you how to shade using different traditional media. Practice the techniques on scrap paper before starting the final illustration. Always remember to start with the lightest shade first, and leave out areas that you want to remain white.

Drawing tip
The brand of art material you use can make a significant difference to the color vibrancy. Cheap colored pencils or watercolors have poor pigmentation and will make the image appear washed out. The alcohol-based markers that are popular in manga illustration are usually fairly expensive, but they can last for many years without drying out.

Soft pastel

1 Pastels work well with ink or pencil outlines. Use a dark brown pencil for a soft effect.

2 Apply your base color using the tip of the pastel. At this stage, it doesn't matter if the coloring is a little rough.

3 Take a darker color and hatch some shading. Keep all the excess pigment on the paper, since it will make the colors more vibrant later on.

4 Gently blend the colors together using your fingertips or a cotton swab. You can go over any outlines using a sharp colored pencil to make them stand out.

Markers

1 Draw and ink your image on a marker pad. Make sure that the ink you use won't be dissolved by alcohol-based markers.

2 Cover the entire area with the lightest color of your illustration. Try to work quickly, since the ink won't blend smoothly after it's dry.

3 Use the same marker to layer on some shadows. Most markers have a tapered brush tip which lets you cover all areas quickly and easily.

4 Create shadows using an analogous darker shade. Be careful not to layer too many colors on top of each other because the ink will dissolve and turn patchy.

POPULAR TRADITIONAL MEDIA IN MANGA

Soft pastel
Soft pastels blend nicely and are easier to use than wet-on-wet media.

Markers
A favorite among manga artists, markers give quick results with bright colors.

Watercolor
Accessible and affordable, watercolors can be mixed to create any palette.

Colored pencils
Suitable for beginners, pencils give you a lot of control over drawing pace.

Watercolor

 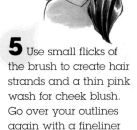

1 Outline your sketch using waterproof ink. You can test this by drawing some lines and then rubbing a few drops of water over it.

2 Mix yellow, red, and white into a skin-colored wash. For a smooth application, try to cover the whole area before the color has a chance to dry.

3 Build up shadows by layering the same skin color. Be careful not to use too much water when diluting your paint—this can dissolve or warp the paper.

4 Blend in some ocher or brown for darker skin tones. Avoid using pure black pigment to create shadows on skin because it looks like smudged ink.

5 Use small flicks of the brush to create hair strands and a thin pink wash for cheek blush. Go over your outlines again with a fineliner to make them pop out.

Colored pencils

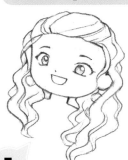

1 Outline your sketch in a dark brown pencil. As the colors are fairly soft, black ink lines might create too much contrast.

2 Start with a layer of yellow. As it's very pale, you can test out which areas would be good for shadows.

3 Now go over it lightly with orange. This will appear quite a bit darker so you can use it to create clear shading.

4 Try ocher or brown for deeper shadows. You can also go over certain outlines again with a sharp, dark brown pencil for emphasis.

5 Cheek blush always looks cute on chibis. Use a craft knife to scrape some pink soft pastel into powder, and apply this carefully using a cotton swab.

Digital media is a massive field in the creative industry. It's expensive to get started, but if you're confident that your hobby will continue for many years, working digitally is more cost-effective in the long run. Many graphics programs offer an endless array of colors, styles, brushes, and techniques, so you'll never run out of ways to express your creativity. To get started, you'll need a combination of hardware and software.

Hardware

Go digital for the right reasons

A common misconception is that working digitally is somehow easier and the right computer programs can make your work look instantly better. Sadly, there is no magic shortcut. Digital programs only give you more tools— you still need to make all the artistic decisions. So be aware that you'll still be the same artist when switching to digital, but having the right equipment maximizes your potential to create beautiful computer illustrations.

Mac or PC?

When choosing a computer, go for the highest processing speed you can afford, since image manipulation requires a lot of memory to run and save. PCs are generally cheaper, especially if you shop around. Macs are dominant in the creative industry, so a Mac is a useful investment if you plan to study art or work in this field.

Laptop or desktop?

Desktop computers are cheaper, with large monitors that are ideal for image editing work. The components are flexible to arrange in case you have a large graphics tablet to make space for. Laptops are convenient if you travel a lot or have limited space to work in. If you're a student, check if you're eligible for an "educational discount," which can save you a lot of money.

Graphics tablet

This is a crucial investment for any digital artist. A small tablet is roughly the size of a mouse pad, and a medium tablet is the size of a sheet of paper. Most artists are comfortable starting with a small tablet and then progressing to larger sizes as their skills expand.

When you first begin using a tablet, you'll need to get accustomed to looking at the screen, not your hand, when drawing. This is why many artists still prefer to design characters on paper and only use their tablet for coloring in. Coloring and shading are done in broad strokes and are easier to control with a tablet than very detailed line work.

There is a loose correlation between the beneficial effects of tablet size and the level of artistic ability. So a beginner artist won't find a large tablet that useful, but a more experienced artist will notice a substantial improvement in their work by switching to one size up. Tablets generally have a very good shelf life, and the main reason artists buy a new one is simply for upgrade, not malfunction. Therefore, buying second-hand tablets is a popular option for artists hoping to try out new equipment without the steep price tag.

Scanner

Flatbed scanners are relatively affordable and very useful if you plan on drawing by hand and coloring on the computer. Make sure that the scanner uses a tinted light (e.g. green) instead of plain white. White light will "bleach" your artwork when scanning and give poor results, especially for sketches.

Software

Vector and raster

In digital art, you may see these two words come up quite often. They are two different ways that the computer stores visual data. When a computer saves a vector image, it stores a mathematical calculation for the perimeter of each shape. This means the image is infinitely scalable, and vector designs will remain sharp no matter how large or how small they get.

Raster images have a fixed size and you simply draw or paint in that space. The computer saves information on the color of every pixel in that space, so it's still the same amount of data regardless of whether your illustration changes hue, shading, or texture. Raster images are bound by "resolution," which is the number of pixels per inch that the computer has data for. If you try to increase the size of a raster image too much then it will become blurry and pixelated because the computer no longer has information to keep the image sharp. You can tell by the file extension whether an image is raster (jpg, gif, png, tif, psd) or vector (ai, pdf, eps). As a manga artist, you will mostly be working with raster files.

Software programs

Most graphics software programs work similarly so you can experiment with anything within your price range, but it can be harder to find tutorials or peer support if you use more obscure programs. Digital art magazines, online communities, and video tutorials are almost exclusively geared toward Adobe products. Below is an overview of the most popular software used in manga illustration.

Adobe Photoshop

The giant among all graphics programs, Photoshop enables you to draw and paint from scratch as well as do photo-editing, text, and layout work. There are copious publications and online resources for Photoshop. The only drawback is the expensive price tag. You can opt for a more basic version of Photoshop or see if you're eligible for educational discounts.

Adobe Illustrator

Just as powerful as Photoshop, Illustrator is the industry standard for vector illustration. Instead of painting and blending, shapes with gradated colors are layered together. This creates a crisp and modern effect. Illustrator is also effective for tidying up outlines, since it can convert an inked image into a seamless vector outline.

Corel Painter

More affordable than Photoshop, Painter is suitable for soft shading and painterly artwork. It lacks the typographic, design, and layout capabilities of Photoshop but its painting functions are just as professional. It's ideal if you're only looking for a versatile program to color illustrations.

openCanvas

An extremely popular and surprisingly affordable Japanese software, openCanvas was designed specifically with manga artists in mind, in terms of color palettes and tools. Final artworks are of the same visual standard as Photoshop and Painter in terms of quality. The only drawbacks are that it lacks English-language tutorials and it's only available for Windows.

Manga Studio

Manga Studio specializes in comic creation for manga artists. It focuses primarily on black-and-white art, digital inking, and digital screentone. This is indispensable for anyone making their own manga story, but possibly less useful for someone only interested in painting color illustrations.

Top tip

In case of emergency

Always remember to make a regular back-up of your work. This can be saved on an external drive, web-based server, or burned on DVD. You can also set up a program (such as Time Machine on Mac) to automatically back up your work.

This section details a common technique for coloring in manga illustrations. Most graphics programs have so many different functions that there isn't one "right" method for coloring, so feel free to experiment with any tools, tutorials, or ideas that you come across. The tools mentioned here are specific to Adobe Photoshop but the workflow steps can be used across a variety of programs.

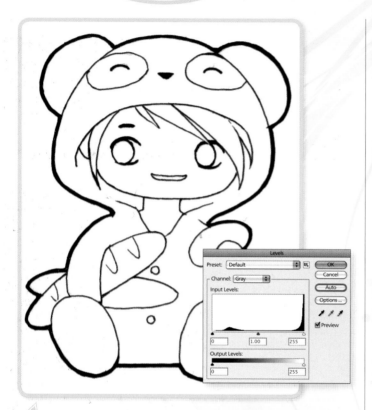

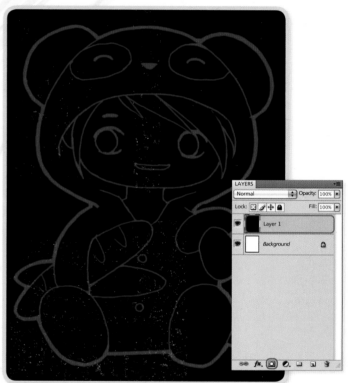

1 Scanning and separating outlines

A bit of prep work is required to turn an image you drew by hand into a file suitable for digital coloring. First, scan your image at high resolution (minimum of 300 dpi) and save it as a tif or high-quality jpg. Since the image is black and white at this stage, you can use the "Grayscale" setting to reduce the file size. The biggest advantage to digital is that you can work in "layers," making it much easier to correct mistakes and adjust colors. Separate your outlines so they are on their own layer. Open your image up in Photoshop and select Image > Adjustments > Levels. Click the "Auto" button and the computer will clean up the contrast on your image. You can also adjust the contrast manually by pushing the graph bars until your image has a clean white background with crisp black lines.

2

Go back to your main image and choose Select > All and then Edit > Copy. The copied image is now temporarily stored in the software memory so you can clear the screen by going to Edit > Fill and filling in everything with white. Now create a new layer by going to Layer > New. Use the Paint Bucket to fill this in all in black. Select the Quick Mask mode under the Toolbox. Now paste your image (Edit > Paste), and deselect the Quick Mask Mode.

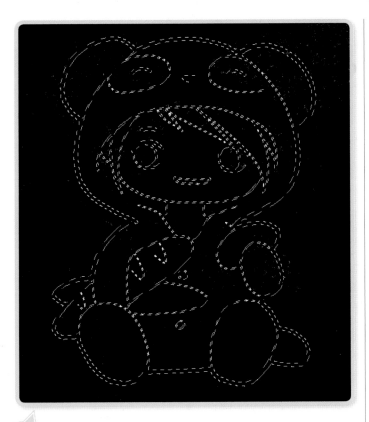

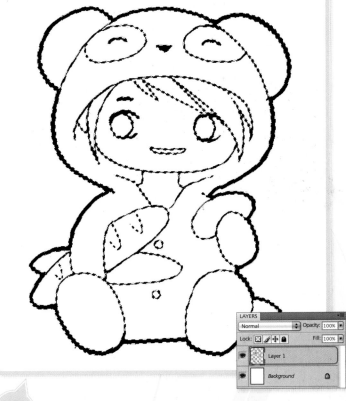

3 You should now have a black screen with "marching ants" selection around your outlines.

4 Press Delete while the marching ants are still active and your original line-art will reappear. Name this layer "Outlines."

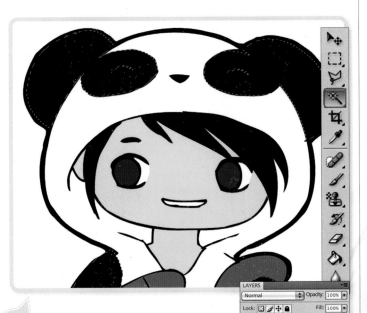

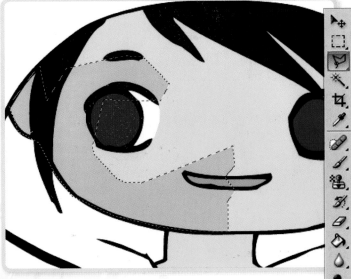

5 Adding color
Use the Magic Wand tool to choose an area from the Outline layer. Then create a new layer below and use Edit > Fill to drop in the right color. Make new layers for each area of color and name them so you can find them easily on the Layer menu. Choosing "Lock Transparent Pixels" means you only paint on existing, opaque areas of color, which makes it easier when shading.

6 Adding shading
For cel-shading, use the Polygonal Lasso to draw shapes and fill them in with a darker shade of the main color.

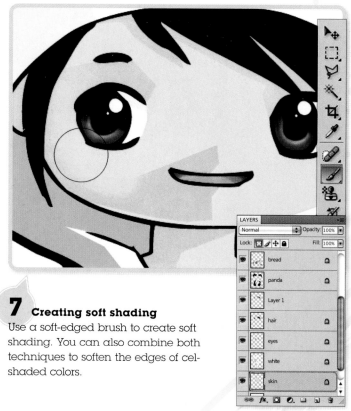

7 Creating soft shading

Use a soft-edged brush to create soft shading. You can also combine both techniques to soften the edges of cel-shaded colors.

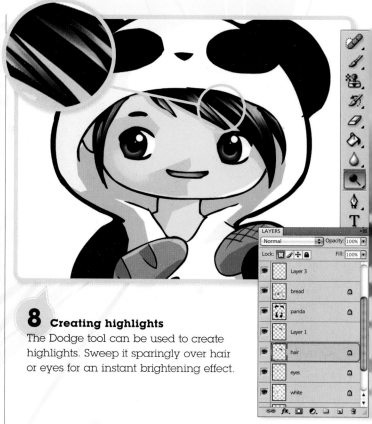

8 Creating highlights

The Dodge tool can be used to create highlights. Sweep it sparingly over hair or eyes for an instant brightening effect.

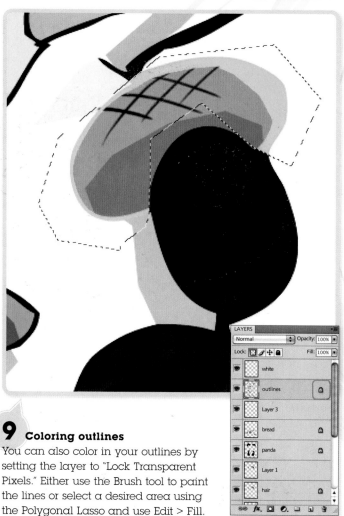

9 Coloring outlines

You can also color in your outlines by setting the layer to "Lock Transparent Pixels." Either use the Brush tool to paint the lines or select a desired area using the Polygonal Lasso and use Edit > Fill.

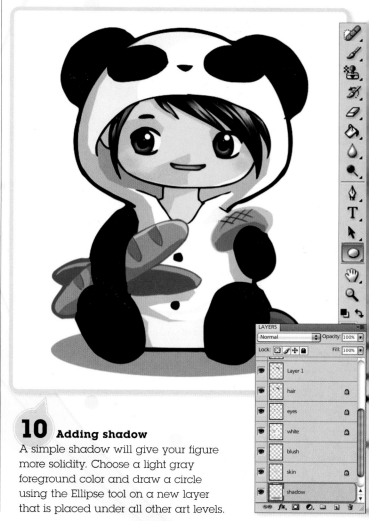

10 Adding shadow

A simple shadow will give your figure more solidity. Choose a light gray foreground color and draw a circle using the Ellipse tool on a new layer that is placed under all other art levels.

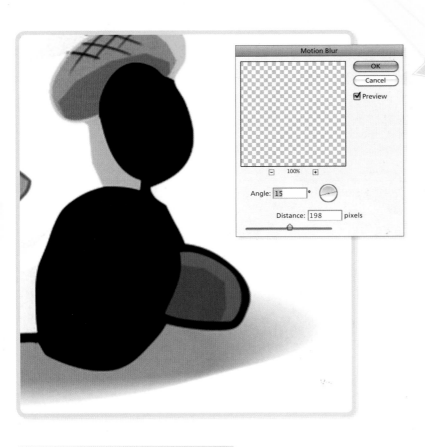

11 **Soften shadow**

Try Filter > Blur > Motion Blur to soften the shadow and make it more realistic. Experimentation is all part of the fun when it comes to learning new media. Don't be afraid to make mistakes or try out a technique that doesn't quite turn out how you imagined. You may discover a unique way of drawing and coloring that becomes your trademark style.

FILE FORMATS

Below are the most commonly used formats in which to save your image in Photoshop.

■ **PSD:** If working in Photoshop, this is what your main image will be saved as. Other programs have their own versions of the "work in progress" file. This is the largest, most important file because it's editable and the one that should be backed up regularly.

■ **TIF:** This is a high-resolution format suitable for printing. It can also take up a lot of space, so to reduce file size you can save your image as "TIF with LZW Compression."

■ **JPG:** This is the most commonly seen image format because it's compatible with many viewers and small enough to send over the web. JPG should only be used if you're uploading your work online or sending preview images over email because the image quality will deteriorate the more often you resave.

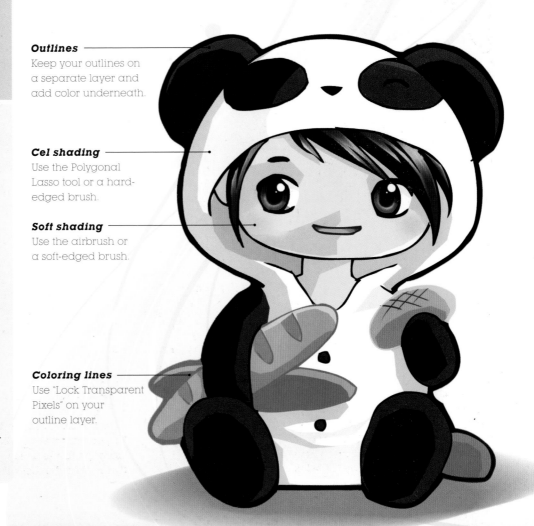

Outlines
Keep your outlines on a separate layer and add color underneath.

Cel shading
Use the Polygonal Lasso tool or a hard-edged brush.

Soft shading
Use the airbrush or a soft-edged brush.

Coloring lines
Use "Lock Transparent Pixels" on your outline layer.

HOW TO DRAW THE BODY

Far from being one style, chibi style is an umbrella term for a spectrum of stylized body proportions. The first rule to learn when drawing a body is the concept of head height.

Depending on the size of the head in relation to the body, you can make a character look older, younger, cuter, or funnier. A regular adult human measures six to eight heads while chibis tend to be between two to four heads. When you first start drawing chibis, it's very easy to accidentally start elongating the body without even realizing it. So always make sure you pause and keep checking your head-to-body ratios!

Body basics
Always start off by sketching the head, since it's the key focal point in super-deformed characters. This also lets you jot down guidelines for body size without getting sidetracked. Be creative and experiment with different head-to-body ratios,

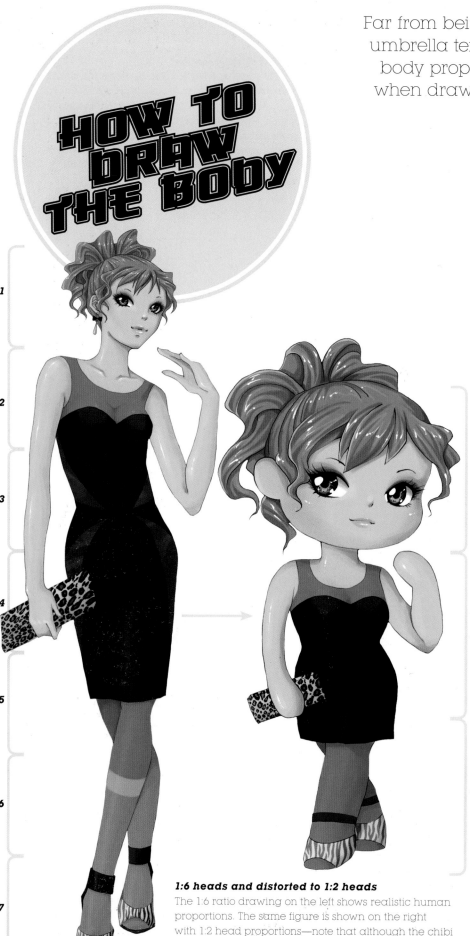

1:6 heads and distorted to 1:2 heads
The 1:6 ratio drawing on the left shows realistic human proportions. The same figure is shown on the right with 1:2 head proportions—note that although the chibi figure is adopting the same pose and wearing the same clothing, she appears instantly cuter.

1:1 heads
When the head is the same size as the body, the chibi will look super cute and stylized. These are the easiest to draw, since you can leave out hands, joints, and details.

thickness of limbs, and level of detail. Remember that there isn't a fixed ideal for a chibi body, so take liberty in this area of manga art and try out all combinations in order to find your own style.

Range of proportions

When drawing chibis, it often helps to view the head and body as two separate entities. Mark out the ratio for head and body, then forcibly draw these in the space given. This lets you move away from ingrained notions of human proportion and loosens up your style for more figurative representations.

1:1 heads
Cheeky, funny, and super-kawaii ("cute" in Japanese), this one is easy to draw, but you'll have to keep everything very simplified!

1:2 heads
A classic chibi proportion, this body is small enough to be cute yet versatile enough to express a range of emotion and poses.

1:3 heads
This body is shapely and graceful. Keep the head large to prevent it looking too realistic.

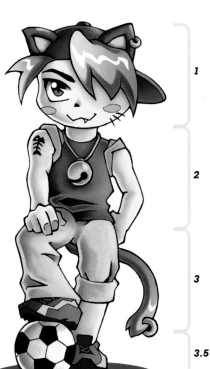

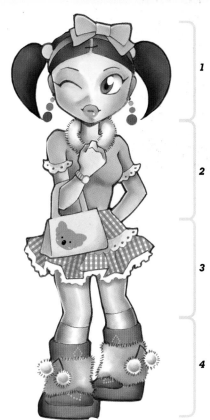

1:2 heads
This is one of the most popular chibi proportions. The head is large enough to be cute and expressive and the body dimensions flexible enough to accommodate a range of poses.

1:2.5 heads
Muscular limbs and a confident pose let this character appear kawaii yet masculine. Despite the sweet nature of chibis, it's possible to show male or female characteristics.

1:3 heads
Cute and stylish, this proportion lets you incorporate a lot of clothing detail and body language. It's well-suited for fashion illustration or characters in a manga story.

The head is by far the most important hallmark of a chibi character. The focal points, in order of importance, are eyes, eyebrows, mouth, and nose. When drawing an expression, use the above order to ensure your chibi has well-balanced facial features. Chibi hands and feet are often very stylized, so experiment with designs that correspond with the level of detail of the rest of the image.

How to draw the head

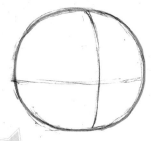 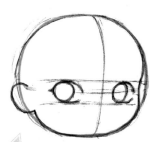 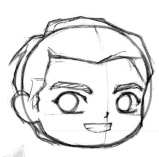 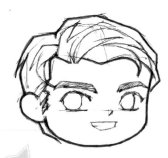

1 Sketch out the head using a round or slightly oval pumpkin shape. Make two guidelines to show you in which direction the character is looking.

2 The eyes should be placed on the horizontal axis. Use more guidelines to ensure that both are at the same height.

3 The nose and mouth go on the vertical axis. Draw the mouth first to ensure you have the correct facial expression in conjunction with the eyes.

4 When you come to drawing the hair, use the head outline as a guide so the shape doesn't become skewed.

Front view

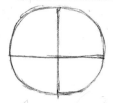 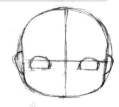 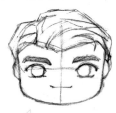

1 Keep the guidelines centered for a front view. Notice how the initial circle should be the same for all three views because the volume of the head never changes.

2 The trickiest part of a front view is that the face needs to be symmetrical. If drawing by hand, there may always be discrepancies in eye height or cheek shape.

3 If you want perfect symmetry, you can trace half the face using a dark pen, flip it around, and retrace it on the sketch with a light-box. Or you can alter it digitally by copying sections of the outline and flipping it over.

Three-quarter view

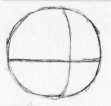 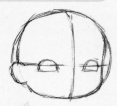 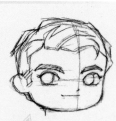

1 Suitable for beginners, this is the easiest angle to draw. Tilt the crossbar sideways so half the face takes up three-quarters to two-thirds of the head.

2 From your initial sketch, dip the outline inward to create the cheek. Use the oval shape to determine the rest of the face and add some ears.

3 There is slight perspective so make sure the eye farther away from the viewer is narrower than the closer one.

Shading faces

Light from the back
This makes the image appear darker and more dramatic.

Light from the left
Shadows fall around the cheeks, in the eye sockets, and under the hair.

Light from the right
Adding a highlight emphasizes the lighting direction.

5 Once everything looks right, ink your chibi sketch and erase the guidelines. Or scan your sketch and outline it digitally on a new layer.

6 Fill in flat areas of color and you're ready to start shading. Don't begin shading until you've found a pleasing combination of colors for the whole character.

Side view

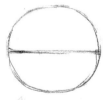

1 To indicate a side view, leave out the vertical axis when you're sketching guidelines. Tilt this line up or down if the character should be looking in a certain direction.

2 Dip the face inward to suggest a nose. Chibis will look cuter if the nose and chin flow into each other slightly.

3 Draw one eye from the side that's level with the nose and ears.

HOW TO DRAW HANDS AND FEET

Hands are notoriously tricky to draw, since they can be viewed from a massive range of angles and poses. The good news for chibi style is that hands and feet are often simplified so small mistakes can be glossed over. However, a basic knowledge of how hands work is an important foundation. Start by doing some sketches of your own hands from all angles and then try simplifying these as shown below.

1. Realistic
A life-drawing sketch of a real hand. You can see the knuckles, all five fingers and nails.

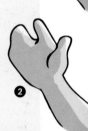 ❶

2. Mitten hands
Popular with chibi artists, these hands give an indication of fingers but without going into detail, which would make the image unnecessarily cluttered. Imagine your character is wearing mittens or practice drawing your own hand inside a mitten or sock.

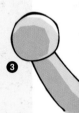 ❷

3. Ball hands
These hands are simplified further, using a round ball as the basis. If needed, a finger or a thumb can be drawn separated for emphasis.

 ❸

4. Pointy hands
Also quite popular in chibi style, these are a tapered extension of the arm into fingers. This preserves the cuteness of the limbs.

 ❹

5. No hands
The most simplified chibi proportion doesn't require hands at all. This is an effective artistic device if you want the viewer's full attention to be focused on the face or body language. And, needless to say, it's also the fastest and easiest chibi body to draw.

❺

6. Feet
Drawing feet is relatively simple, since you'll rarely see them without shoes. They should reflect the same level of simplification as the hands. So on one character, if the hands are chunky, the feet should be defined, and if the arms are pointy, the legs need to be also.

❻

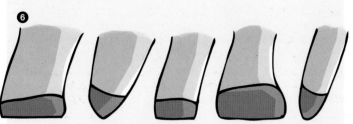

Chibi eyes can vary in shape from round to oval, linear, or leaf-shaped. The basic eye consists of an iris, pupil, and light reflection. These three components should always be there to give the eye depth and the feeling that the character is looking directly at you. Eyes should always be drawn in conjunction with eyebrows because they give the face its expressiveness and enhance symmetry. Take care when positioning eyes and eyebrows, since a slight discrepancy or asymmetry can make the face appear lopsided.

Drawing and coloring eyes

A common misconception about manga style is that all eyes look the same. As shown opposite, the eyes are possibly the most flexible feature of the entire character. This sequence shows how to draw and color a basic round chibi eye, although you can start off with virtually any shape you like. However, the iris should always be round or oval to remain anatomically correct.

1 Start by sketching a rounded ball or leaf shape.

2 Sketch in the eyelashes and iris. Iris size is determined by emotion, so try to decide what sort of facial expression the character is showing (see pages 34–35).

3 The shine spot should partially cover the darkest part of the pupil. This gives the eyeball a 3D effect.

4 Emphasize the top and bottom of the eye when inking, and remember to leave uncolored any shine spots.

5 When coloring the iris, you should use a dark gradation from the top of the eye and an analogous highlight in the lower part. Adding a touch of gray shading under the top eyelid enhances the volume of the eye.

Different genders

To differentiate between genders, male characters should have sparse eyelashes and thicker eyebrows. Eyebrows tilted downward appear fiercer and more masculine, whereas shorter and high-up eyebrows make the face gentler and more feminine.

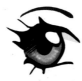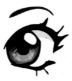

Female

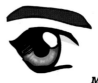

Male

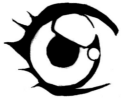

CRAZY EYE VARIATIONS

Based on the basic eye, you can have free rein to experiment with different levels of detail. Simple chibi eyes create a cute nostalgic charm, and more complex ones give the character depth and personality.

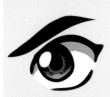

Masculine eye
A strong eyebrow and clean lines.

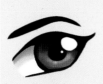

Unisex eye
A medium eyebrow and slightly winged eyelash.

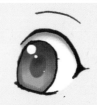

Feminine eye
A thin eyebrow, thick eyelashes, and sparkly reflections.

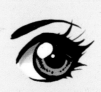

Round eye
Suitable for younger or innocent-looking characters.

Attentive eye
Strong black shading and a defined eyebrow.

Gentle eye
Coloring the eyelashes a lighter color softens the gaze.

Monochrome eye
Use hatching techniques to create the effect of shading.

Fantasy eye
A fantasy eye can have magical cat-like pupils.

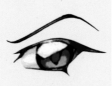

Demonic eye
The narrow shape and red iris give this eye a sinister feel.

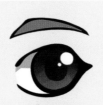

Caricature eye
May be rounder, triangular, or wedge- or almond-shaped.

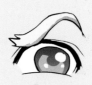

Dramatic eye
Letting the eyebrow touch the eye creates a theatrical feel.

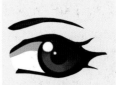

Almond eye
Starting with a leaf shape gives you a tapered, smiling eye.

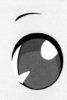

Angular eye
Extreme angles produce a fierce and stylized eye.

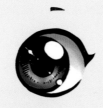

Glassy eye
Leave out the pupil to create a very gentle, glassy gaze.

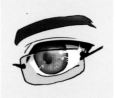

Curious eye
A small dot-like eyebrow gives the face a wide-eyed inquisitive look.

Bespectacled eye
Use very subtle highlights to depict the edge of the lens.

Cartoon eye
Exaggerated squinting eyes are great for comical expressions.

Beady eye
Tiny round eyes can be used for animals or very cute characters.

THINGS TO AVOID

■ **Drawing square or rectangular-shaped eyes**
They don't look cute or endearing. Sometimes manga eyes may appear angular at first glance, but it's only an illusion of round pupils being half-hidden by eyelids.

■ **Adding too many reflections or sparkles**
It will make an eye look glazed and unfocused. When in doubt, only go for one strong reflection on one side of the eye and keep other shine spots significantly smaller.

■ **Making eyes too big**
Eyes that are too big or too close together aren't appealing or chibi-like. Manga style is less about making the eyes as huge as possible and more about the precise positioning of facial features to express cute emotions.

On a chibi character, the hair is often the largest area of color and has a substantial impact on the overall character design. For realistic chibis, think of naturally occurring hair and eye combinations such as blond and blue, brown and hazel, or black and brown. For wackier anime-style characters, try all kinds of hair colors such as pink, green, blue, or purple.

Designing hair

After drawing the face, mark out the hairline, making sure that it doesn't look unnaturally high or low on the head. Now depending on the hairstyle of your character, you can work backward from the hairline to create a sleek hair style or add bangs to the front. Hair is also a great way to indicate movement in your image. If your chibi is in a dynamic pose, then the hair should be flung in the opposite direction, with strands flying loose.

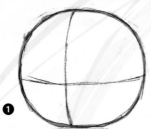 ❶ 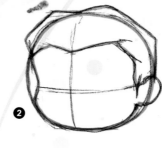 ❷ 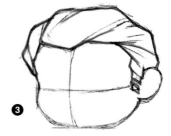 ❸

Male
Use guidelines (shown here in red) to ensure that the hair doesn't extend inward past the scalp. Instead of bangs, some short hairstyles will begin at the hairline and flow backward.

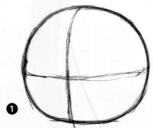 ❶ 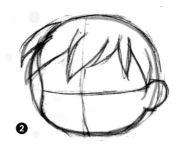 ❷ 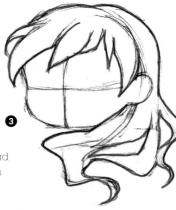 ❸

Female
Use guidelines (shown here in red) to ensure that the shape of the head doesn't become lost or distorted. When drawing bangs, the strands on both ends should be roughly symmetrical to frame the face.

HAIR STYLING TIPS

■ Manga hair may look crazy, but you can only color it effectively if you have an overview of the growth pattern. When drawing the hairstyle, think about where the strands originate so you know where to lay down shading.
■ The light source for hair, eyes, and skin needs to be consistent. So make sure the large reflection in the eye faces the same direction as the hair shine. If you're drawing a group image, this also needs to follow through for every character.
■ Avoid the urge to overwork an image. Highlights look best when used sparingly in the right places, rather than splashed over every surface. If you're working digitally, never use the Lens Flare effect to emphasize a highlight.

HOW TO DRAW AND COLOR HAIR

Different coloring styles

Chibi hair is ideally suited to a range of coloring styles, from very simple shapes to intricate painterly effects. Sometimes the most complex or time-consuming technique is not necessarily the best, so just play around with different methods until you create one that you find most visually pleasing.

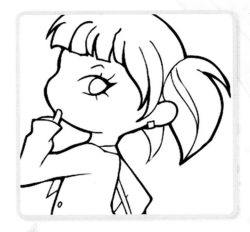

1 Open up your prepared outlines.

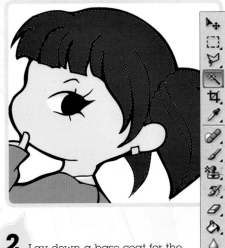

2 Lay down a base coat for the hair. If working traditionally, do not color the highlight areas that you want to remain white.

3 Create a new layer and start adding shadows and defining individual strands of hair using the Polygonal Lasso or Brush tool.

4 If working digitally, add highlights using the Dodge tool for a silky effect. Use this sparingly and enough so you have a nice sheen.

5 Hair is naturally tousled, so try to work some irregularity into your shadows and highlights. Perfectly smooth hair will look like a helmet.

6 Color in the outlines to make the character appear more realistic and illustrative.

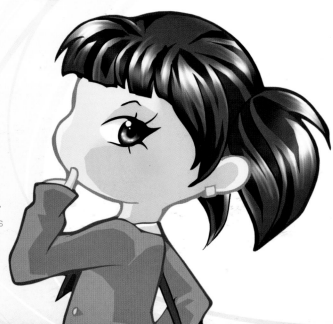

Final image
Shiny, detailed hair immediately makes an image appear more polished and complete.

The core concepts of chibi style are simplification and exaggeration. You can also think of chibis as emoticons for stories, and use them to punctuate scenes with emotional emphasis. Indeed, chibis are often more appealing as mascots or icons simply because their larger faces are better suited for making "eye contact" with the audience. In addition, chibi bodies can be stylized to create dramatic body language that further enhances communication with the viewer.

Eyes and eyebrows

These are the most expressive areas of the face. Eyebrow angle and pupil size can be used to adjust the intensity of an expression (**1**). In contrast, simplifying both features will create a placid, peaceful illustration (**2**).

Rules of kawaii

For maximum cuteness, the eyes, nose, and mouth should form an upside down, very flat isosceles triangle (**1**). The mouth and nose should be close to the center of the face. The lower they are, the more cartoony and less chibi it begins to look (**2**).

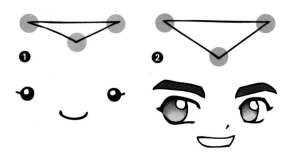

Visual grammar

In manga style, there are many symbols to denote certain feelings. Use these to further emphasize a certain emotion.

Happiness—Rays

Fear or shock—Lines

Tipsy—Bubbles

Love—Hearts

Excitement—Sparkles

Embarrassment—Sweatdrop

Revelation—Spark

Anger—Throbbing vein or scribble

Sample expressions

Notice how some elements remain the same, but changing another feature alters the mood of the character.

Happy

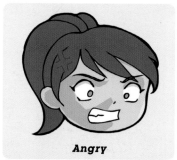
Angry

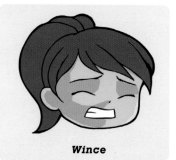
Wince

COMMUNICATION BETWEEN CHARACTERS

The role of an artist is to communicate ideas without using text. In everyday life, pay attention to visual symbolism such as gestures, colors, expressions, and style.

The interplay of facial expression and body language should serve to convey a message that is immediately understood by the viewer. Like delivering the punch line of a joke, if people don't "get" it immediately, the impact is lost. So try to analyze the motivations behind individual characters. If one character undertakes a certain action, how would the other one react? And how can you show this interaction in the simplest yet most exciting way?

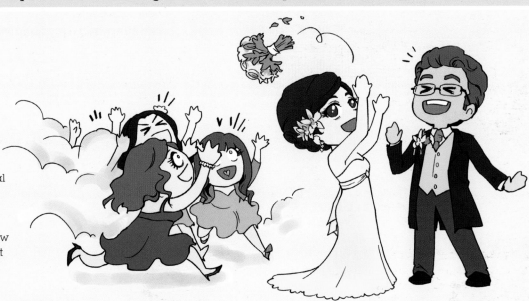

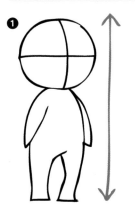
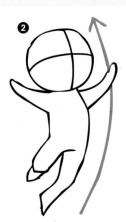
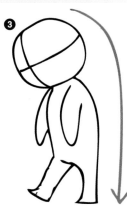

Body language

When standing perfectly straight, the body's center of gravity goes straight downward (**1**). Dynamic poses tilt around the center of gravity, giving the impression of a snapshot of something in movement. Poses facing upward convey levity and happiness (**2**), whereas slouched or hunched bodies imply sadness (**3**). Observe people around you to see how subtle gestures contribute to their overall demeanor.

Interaction

When drawing two or more chibis interacting with each other, make sure both bodies are the same in terms of size and head-to-body ratios (**1**). Then, using simple lines, draw in the desired interaction. Some poses may be hard to create, since the large chibi heads limit the range of movement. In this case, you may need to rearrange the image composition or character design until it's clear what scene is being shown (**2**).

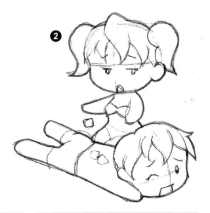

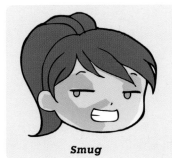
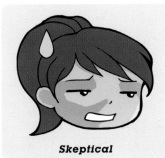
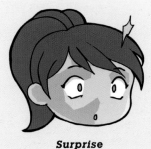
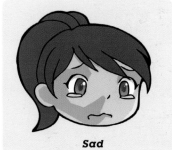

Smug

Skeptical

Surprise

Sad

Clothing and costume design is the vital finishing touch to your chibi. There may not always be enough room to experiment with complex garments, but it's nonetheless possible to give each chibi a unique touch. Bold colors, patterns, or a striking accessory can be used effectively to jazz up a streamlined outfit. Fabric folds are also easier to draw on chibis than regularly proportioned manga characters, so it's an ideal way to learn the basics.

Fabric folds

Fabric is a single surface that is affected by gravity and the surface it's draped over. Creases will occur at any location where it gets pinched or folded. Below are some common garments and the places where folds tend to occur.

Shirt

A regular shirt or blouse has thinner fabric and will crease more readily.

Accessories

Items such as a hat or bandana produce small, tightly bunched folds.

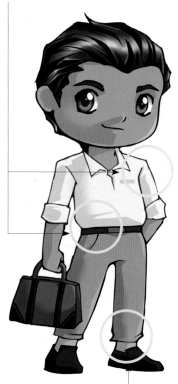

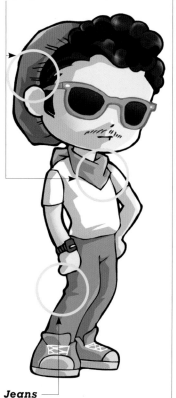

Trousers

Trouser folds occur at the crotch, at the knees, and when the hem drapes over the shoes.

Jeans

Stiff fabric like denim isn't affected by gravity as much, so it produces almost horizontal folds.

Patterns

Just like textures, patterns are great in giving your character an extra touch of realism. You can find free fabric pattern packs online, export them from a program like Manga Studio, or draw your own. If working digitally, you can enhance the effect by adding some shading over the pattern using a layer set to "Multiply." Scanned origami paper is great to use for kimono fabric because the slightly irregular designs create an illusion of volume.

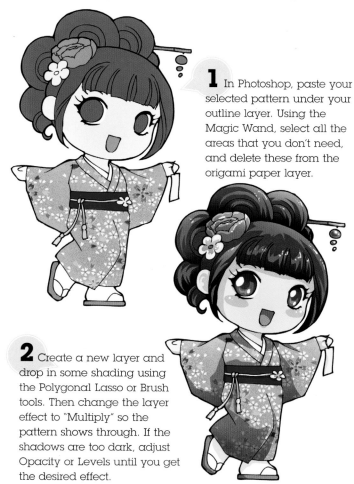

1 In Photoshop, paste your selected pattern under your outline layer. Using the Magic Wand, select all the areas that you don't need, and delete these from the origami paper layer.

2 Create a new layer and drop in some shading using the Polygonal Lasso or Brush tools. Then change the layer effect to "Multiply" so the pattern shows through. If the shadows are too dark, adjust Opacity or Levels until you get the desired effect.

COMMON PITFALLS

Fabric is one continuous surface, so avoid drawing any folds that don't make sense. What may appear "random" is actually a realistically creased object viewed from one angle.

Don't criss-cross lines (1) or draw folds in random locations (2). It can help to visualize the surface as a flat grid (3). Make sure fabric obeys gravity and hangs in folds from the highest point of support (4).

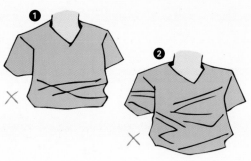
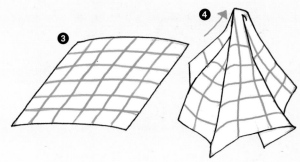

Accessories

For many specific styles such as Gothic Lolita, accessories are key in defining the outfit (see page 61). Small attention to detail, such as drawing the correct footwear instead of a neutral blob, also brings more life and personality into your chibi. Visual references are only a mouse click away, so there can't be an excuse for not finding the correct inspiration!

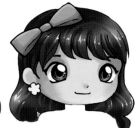

Shoes

Some styles of shoes require foreshortening, which is a perspective when it's viewed straight from the front. The best way to do this is to look at a real shoe or use reference photos.

Flip flops **Loafers** **Mary Janes**

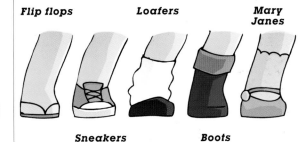

Sneakers **Boots**

Clothing textures

Attention to detail is key when you're designing clothes, since they express your character's profession or personality. Many textures and trimmings can be recreated with certain ink or painting techniques.

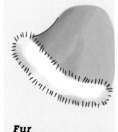
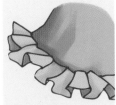

Fur
Use a broken dashed or dotted outline to suggest fluffiness. The same effect can be used to create pom-poms.

Ruffles
Draw a wiggly line for the edge of the ruffle first and then fill in the folds. Remember to show a few darker areas of the inside of various ruffles.

Chiffon
Start with the outer edge and extend the folds gently upward. Chiffon is soft and floaty so the flows fall downward with gravity.

Pleats
Draw a jagged line to form the edge of the skirt and use it as a guide to create short, stiff creases.

Lace
Use an irregular line with round and sharp angles to create a tight lace trimming. Lace looks best when shaded with pale blue or cream.

Fleece
A gentle scalloped edge gives a soft, fluffy feel to the fabric. Fleece has a matte surface so you don't need any highlights when coloring in.

Anthropomorphic characters are extremely popular in Japanese culture, where inert objects, food, or animals are given human features. This can be seen as an extension of chibi style because the central aim is also simplification and cuteness. By giving an everyday item a facial expression, it not only becomes cuter but also communicates with the viewer on a sympathetic level. Here you can learn how to enhance your chibi universe with all sorts of kawaii friends!

Round and chunky

Western aesthetics tend to elongate, curve, and distort, with the result being stylized but less kawaii on an emotional level. To get the Japanese feel into your work, start off with round, chunky shapes and never stretch anything longer than necessary. Avoid pointy corners, sharp edges, and thin contours. The examples below show how simple objects can be given the cute-factor.

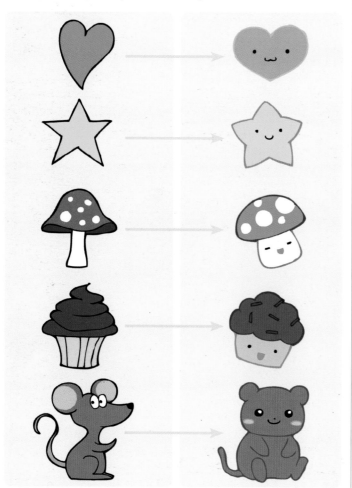

Kawaii facial features

The cutest chibi features should form a flat upside-down triangle (see page 34). Sometimes it helps to understand the rules of why something doesn't look cute, as shown below, in order to learn how to draw the opposite way.

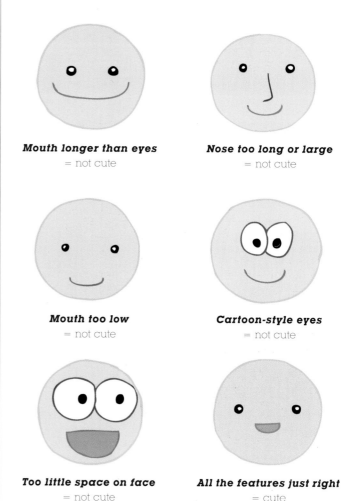

Mouth longer than eyes
= not cute

Nose too long or large
= not cute

Mouth too low
= not cute

Cartoon-style eyes
= not cute

Too little space on face
= not cute

All the features just right
= cute

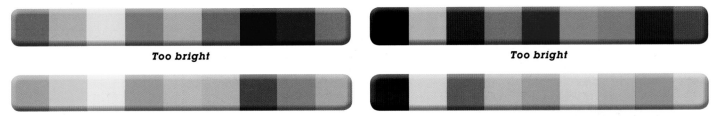

Too bright

Too bright

Pastel: good chibi palette

Pastel: good chibi palette

Using color

The correct color palette goes a long way in enhancing cuteness. Brightly saturated or clashing colors are visually jarring and unpleasant to look at. Gentle palettes such as pastel, muted, or analogous tones are much more suitable for chibi style.

Less is more

Some of the cutest examples of Japanese character design are also visually most simple. Think of your character in terms of shape and volume, instead of detail. If in doubt, try to imagine how your character would look if sculpted into a 3D toy. If it translates easily then it's simple enough, but if you have problems visualizing all the elements, your design probably has too much excess detail.

Simple variation

When drawing a lot of characters together, giving each one a different facial expression makes the image more interesting to look at.

EMOTICON AESTHETICS

You're probably already familiar with some of the emoticons below. Emoticons are perfect examples of effective simplification in order to communicate a mood.

When drawing simple chibis, you may not have the flexibility of using pupils and eyebrows to express emotion. But interestingly, the growing use of online emoticons has familiarized people with interpreting emotion out of very abstract notations. You can take advantage of common digital faces and adapt them for your character. Here are some of the most popular examples.

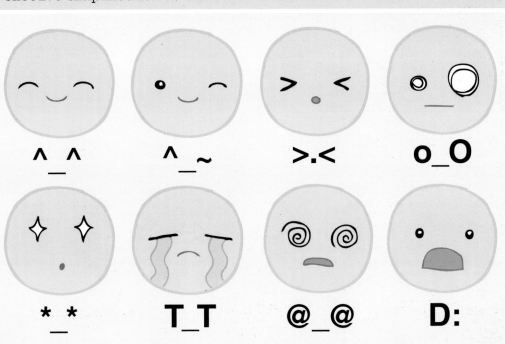

^_^

^_~

>.<

o_O

_

T_T

@_@

D:

HOW TO DRAW CHIBI ANIMALS

Just like humans, animals can be given the chibi treatment for an extra boost of cuteness. Animals are easily differentiated with various colors and features so their bodies can be stylized much further. Depending on the context, you can draw animals with human features, or very minimalistic faces.

Facial expressions

When drawing animal facial expressions, the skill lies in the positioning of facial features rather than their complexity (see page 34). Human-style eyes make the character more expressive (1), whereas small beady eyes look more kawaii (2).

Evolution of cute

Sometimes a simple little icon might not be enough to express the scope of nonhuman characters. In these cases, they can be given humanoid features to expand the range of motion. The spectrum below shows the possible depictions of a chibi animal, and which one you choose will depend on the drawing's context. The concept of head-to-body ratio also applies to animals (see page 26).

Simple icon (1)

The easiest way of showing an animal is to reduce it down to a basic shape and differentiate using distinct features such as ears, fur, nose, and mouth. A lot of Japanese "kawaii" artwork is highly minimalist.

Realistic animal (2)

Animal bodies in their natural state, usually on four legs, can be used in conjunction with human characters to emphasize their role as pets. You can simplify the limbs to make drawing poses simpler.

Human-like (3)

Drawing an animal body in an upright walking position increases

Chibi creatures
Animal bodies can vary greatly from cute and simple to human-like.

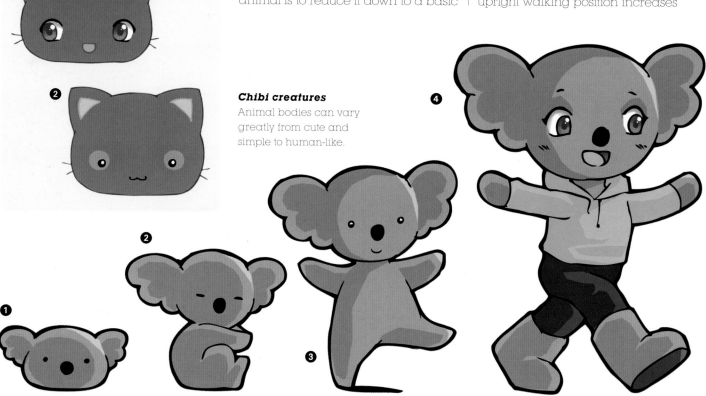

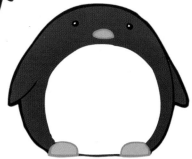

Upright body
This body shape is suited for rodent or fox-like animals. Just a few tweaks can change a raccoon into a squirrel.

Round body
A slightly irregular form looks more realistic than a perfect sphere. This shape can be used for an owl or penguin.

the range of movement and makes it look more human. It's suitable for narrative manga, sidekicks, or any characters that requires a flexible range of interaction.

Anthropomorphic (4)
An animal head on an otherwise human body is most flexible and can be adapted to include outfits, accessories, and other details. This form of character design is popular within "furry" fandom.

Keep it interesting
Most animal chibis won't have outfits or hairstyles, which makes them easier to draw. But remember to maximize facial expression and body language, since animals can look bland if you don't give them distinct

quirks or character traits. Similarly, you can research various types of the same species to give your chibis memorable differences.

Overlapping styles
Many animals share the same basic body shapes so you can widen your repertoire by tweaking a few details. A hedgehog can become a bear and penguins can become owls simply by changing scale. Rabbits might overlap with pigs and squirrels with raccoons. You'll discover that even though animals vary greatly in shape and size, they're actually much easier to draw than you think.

Telling stories
Writing a comic only using animals creates interesting new issues to think

about. For instance, where is it set? What species are featured? How do they interact? Try to aim for balance between predictability and fantasy. This is also a good opportunity to learn more about natural history and use factual research to enrich your creative work.

Animals in literature
If you need any inspiration on writing stories with animals, there is plenty of existing material in literature and mythology. You could consider illustrating a chibi version of Aesop's *Fables*, Chinese horoscopes, or certain Grimm's fairy tales.

Simplicity
You may be surprised at what range of characters you can create simply by varying small details such as ears, eyes, or colors. In the process, you'll also learn how to spot the most essential visual information of a subject and discard the unnecessary.

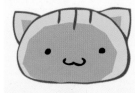

Kitty
Cats are popularly depicted in manga with a wavy mouth, pointy ears, and distinctive fur markings.

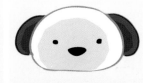

Dog
Large floppy ears and a black nose are the most recognizable features of dogs. This one was given contrasting colors to make the ears stand out more.

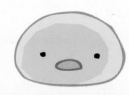

Chick
Already round and fluffy, chicks are perfectly suited for chibi style. Use a bright yellow with an orange beak.

Bear
Bears have cute round ears and a visible muzzle. When drawing extra details on the face, check that these don't affect the relative distances between eyes and nose.

Chapter Two

THE CHIBI SHOWCASE

From modern-day schoolgirls and medieval knights to edgy street fashion and adorable animals, this comprehensive gallery of characters will provide inspiration for all your chibi projects. Every chibi comes with additional tips on styling, color palette, facial expressions, or poses.

JAPANESE SCHOOLGIRL
Kuniko says "Konnichiwa!"

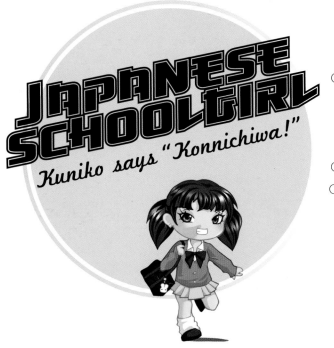

Kuniko is the embodiment of genki, a Japanese definition of cute bubbliness. She loves going for frozen yogurt and shopping in the trendy Shibuya district with her friends after class. But she also studies hard and dreams of making her parents proud by being accepted to Tokyo University.

Style notes
Kuniko wears the typical "cardigan-style" school uniform consisting of a blouse, tie, sweater, pleated skirt, loose socks, and loafers. Some uniforms have a detachable bow that is pinned onto the shirt like a brooch. The handles of a girl's school satchel are inevitably festooned with cute, dangly charms.

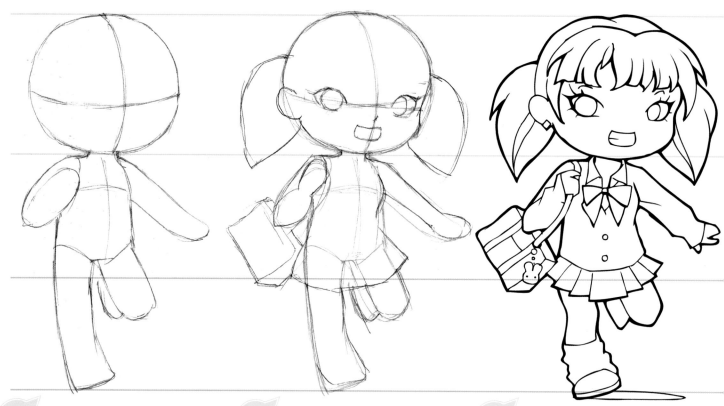

1 Sketch out the body using basic shapes. A dynamic skipping pose suits Kuniko's lively personality. Some simple foreshortening was used on her left leg to suggest depth and movement.

2 Chibis are cute and chunky, so when adding detail such as clothes or hairstyle, it's important to think of the overall silhouette. Kuniko has two pigtails and a flared skirt, which give her a unique outline.

3 When inking, leave the pupils blank. This makes it easier to check if the eyes are symmetrical or if the perspective is correct. Adding pupil details too early can distract you from seeing the simpler shapes.

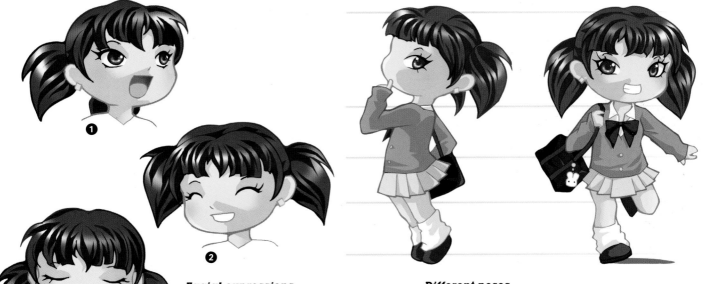

Facial expressions

Drawing a face looking upward creates a sense of positivity (**1**). Kuniko thinks it's time to buy more crystals to decorate her cell phone (**2**). Notice how changing the shape of a closed eye can affect the mood (**3**).

Different poses

If you're drawing the same chibi in different poses, it helps to keep them side by side so you can check that the head size and limb lengths remain consistent.

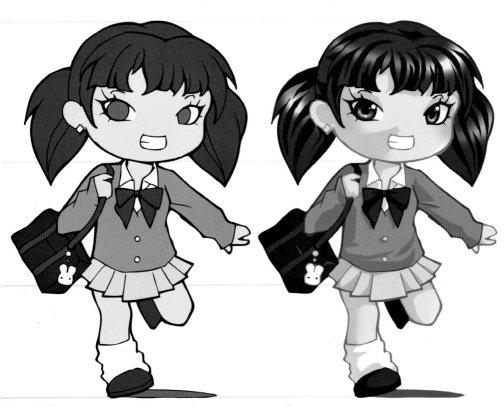

Color Palette

Garish colors are not permitted as part of the school uniform, so an everyday outfit mostly consists of complementary shades of blue, navy, gray, pink, or cream. However, the simplicity is deceptive—there are countless ways to mix and match school uniform pieces, and entire fashion magazines devoted to classroom style!

Skin

Hair and shoes

Eyes

Cardigan

Skirt **Earring**

Bow and satchel

4 Use the Magic Wand tool to select areas and fill them with color. Kuniko's cardigan, hair, and socks are different shades of warm gray, which are more flattering on a human chibi than cool gray tones.

5 Kuniko is colored in classic manga cel-shading style with tinted outlines to make her appear more 3D. Use the Airbrush tool to give her rosy cheeks and the Dodge tool for her shiny hair.

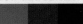

BUSINESSMAN
Roland left a message

Jetting from one client to the next—from Paris to Stockholm—Roland is never without his Smartphone and some immaculately tailored suits. He often works 70 hours a week, and what he does in his private life is quite a mystery!

Style notes
Make sure you have some references for a business suit, as it's very tricky to get all the angles of the collar, tie, and lapels correct. Suits are made of stiff fabric, so they crease sharply, almost like paper, rather than wrinkling up.

Businesslike poses
Roland's body language when walking is languid yet arrogant (**1**). Waiting in the exclusive airport lounge (**2**). Roland's laptop frames this composition so it appears complete without showing the entire body (**3**).

Color Palette
Colors for the suit, shirt, tie, and shoes must be carefully chosen so they complement each other. This is usually a muted palette of grays, blues, and blacks, but that doesn't rule out the occasional bright splash on an accessory or socks.

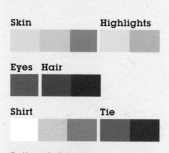

Skin Highlights

Eyes Hair

Shirt Tie

Suit and shoes

1 Remember to give your chibis the correct body language for their personality or profession. In this case, a business traveler should appear casual but serious. Try extra props, such as a cell phone and luggage, to enhance the professional feeling.

2 Business suits are often deep shades of gray or blue, which creates a neutral backdrop for color accents on the shirt, tie, or pocket square. Roland has a penchant for pale blue shirts that complement the lilac of his tie.

3 Even though the suit and suitcase were initially the same shade of gray, you can see what a difference texture makes to the final image. The Dodge Tool in Photoshop allows you to create highlights that mimic plastic or metal casing.

Style notes

Doctor outfits vary depending on their workplace. A family doctor may wear regular clothing under a white coat whereas someone working in a hospital would require sterile "scrubs."

After many years of medical school, Dr. Kip is excited to build her own practice and start taking care of patients. She has the right blend of sympathy and professionalism to make everyone feel taken care of.

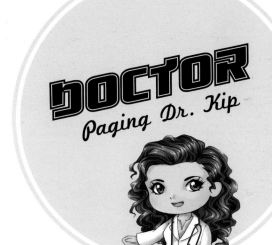

DOCTOR
Paging Dr. Kip

Facial expressions

Doctors should be upbeat to keep their patients feeling positive (**1**). Making a diagnosis, this expression shows a balance of seriousness and sympathy (**2**). Calling another patient in from the waiting room: Who's next? (**3**)

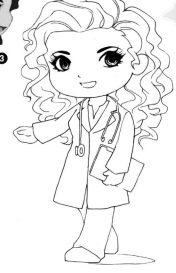

1 Small props such as the stethoscope and medical folder help to communicate that this character is a doctor. The sterility of the outfit is contrasted nicely by the wild wavy texture of her hairstyle.

Color Palette

Creating a chibi in a serious, everyday role can be challenging, since you can't use crazy colors to make things memorable.
A discreet color palette means you should look to other areas, such as hair and facial expressions, to enhance the uniqueness of your character.

2 Color Dr. Kip's white coat using a very pale gray, which lifts it up from the background and makes it easier to shade.

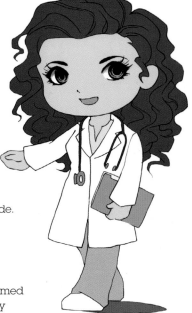

3 Curly hair is untamed and voluminous, so try to make each strand slightly irregular. Finish by sprinkling on some highlights that follow the natural wave of the hairstyle.

Skin **Hair**

Mouth **Eyes**

Coat and shoes

Trousers

Stethoscope

See also

How to draw and color eyes page 30
How to draw and color hair page 32

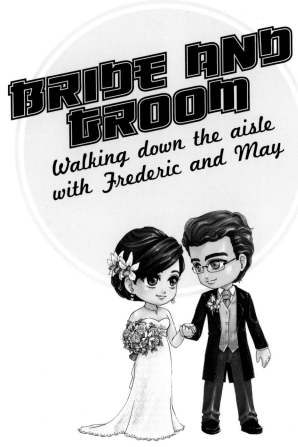

BRIDE AND GROOM

Walking down the aisle with Frederic and May

It's Frederic and May's big day, and they are overjoyed to be tying the knot. Despite all the planning headaches leading up to the big day, all of the stress disappeared the minute they saw each other on their wedding day. May is radiantly glowing with happiness, and Frederic is in awe at the gorgeousness of his future wife.

Style notes

Use classic couple poses, such as hand holding, hugging, and dancing to bring out the romance in your characters. When designing your characters, you can choose to make them look classic and timeless or like they are pushing the latest trends. Wedding gowns don't have to be long and white, and the groom's suit doesn't always have to be black. Look at wedding gown designer websites for inspiration.

See also

Showing emotions page 34
How to draw clothes page 36

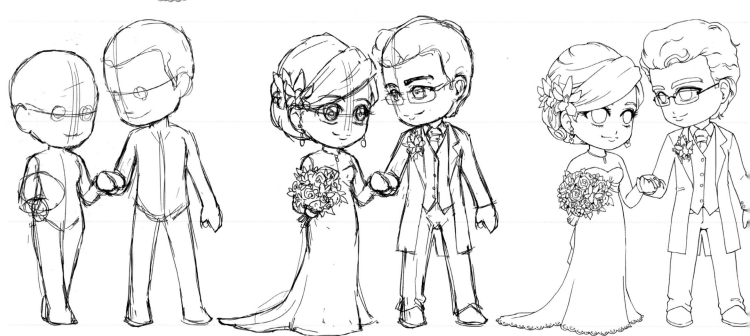

1 Sketch out your characters in your chosen pose. At this point, work loosely and quickly, trying out a few different poses and angles until you find one you like. Block in rough shapes for props, such as the bouquet.

2 Pencil in the details, such as flowers, clothes, and facial features. Use guidelines to ensure that facial features are drawn according to the angle of the character's face and that hairstyles correctly follow the form of the head.

3 Frederic and May were inked digitally in Photoshop using a pressure-sensitive graphics tablet. This lets you vary line width simply by pressing slightly harder on the pen. Try adding darker and thicker lines where elements overlap, such as the flowers in the bouquet or fabric creases by the elbow and armpit.

Use a classic pink, rose, green, and cream palette for a soft romantic feel. The pale colors that you use to tint your "whites" will affect the feel of the white. A blue or purple tinge will make them feel cooler and more serene, whereas peach, pink, or yellow shading gives the white a warmer ivory feel.

olor Palette

HAPPY EXPRESSIONS
It's a wedding, so all sorts of positive emotions are flying around.

Bring out that loving feeling with soft, gentle facial expressions and body language (1). Practice drawing different types of happy expressions: shy/giggly happiness (2), awestruck-blushing happiness, outright ecstatic grins (3), or surprised, emotional moments (4).

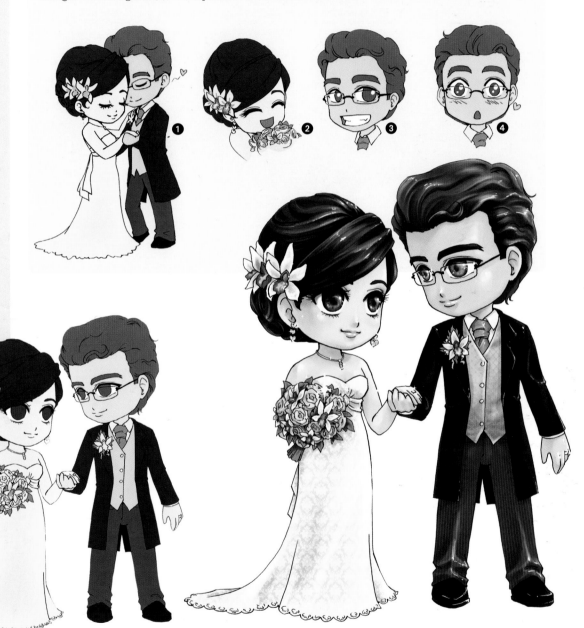

Bride's hair

Groom's hair

Skin

Dress

Flowers

Suit

4 Add colors by selecting the area with the Magic Wand tool and using Edit > Fill. Fine-tune your palette by using the Eyedropper tool to select an existing color and then use the Color Picker to see how a new color will look side by side. Here, Frederic's skin tone is just a tiny bit darker than May's, which gives the characters more individuality.

5 Once you're happy with the flat colors, start painting in deeper shadows and brighter highlights to bring out a more 3D effect in your drawing. Use a star-shaped brush (or white acrylic paint/correction fluid if you're working traditionally) to add sparkly effects on areas such as eyes, jewelry, and lips for a magical romantic feel.

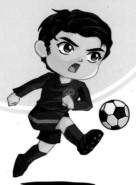

Marcel scores!

Young and talented, Marcel has been recruited into a leading soccer club. He plays left attack and has a knack for scoring goals in the last 20 minutes of the game. Some of his best memories are of simply traveling with his teammates and socializing after the games.

Style notes

Soccer uniforms consist of a long or short-sleeved jersey, shorts, studded boots, and knee-length socks with shin guards underneath. If you are designing a fictional team, you can have fun with the colors. If you're drawing caricatures of real players, make sure you do some research on correct uniforms.

Color Palette

As with most sports, soccer uniforms tend to have a masculine palette of primary colors and strong contrasts. The palette here consists of blues with complementary cool grays.

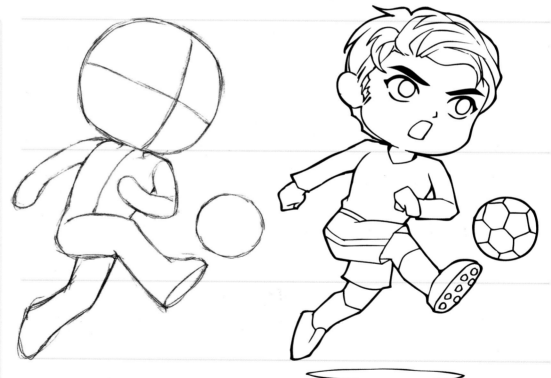

Skin

Mouth

Hair

Eyes

Sweater and socks

Shorts and boots

Ball

1 Sketch your chibi's body using guidelines to help you determine where certain areas are twisted. As with any complex poses, make sure you maintain the head-to-body ratio at this stage.

2 Use the base sketch to help you when filling in details. Soccer uniforms have a lot of detail in the legs and feet areas, so you need guidelines to keep the elements in proportion. The image is quite "shonen," which is the name for any genre of manga aimed at boys, so the inking style can be correspondingly strong and chunky.

POSES

When drawing a chibi in a dynamic pose, sketch loosely so you can capture movement rather than details.

Going in for a slide tackle! Tilting the body at a steep angle removes the center of gravity from this pose and increases the "freeze-frame" effect (1). Dynamic foreshortening creates the effect that the body is suspended in midair (2).

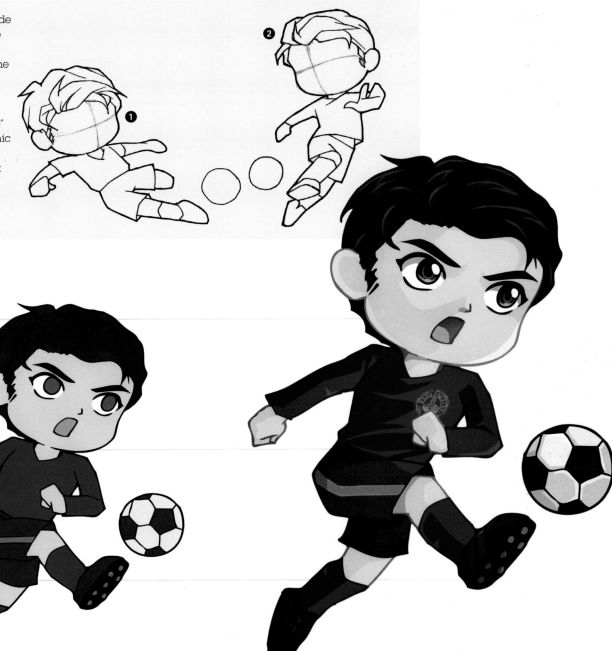

3 Fill in the colors using the Magic Wand tool in Photoshop. Alternating blue and gray for different areas of the uniform gives the image visual consistency.

4 Shade the image using the Polygonal Lasso tool in Photoshop. This gives you angular chunks of color and is effective for replicating the cel-shading style that is particularly popular in shonen manga illustration. Marcel's upper body is slightly twisted so clothing folds on his shirt should enhance this motion.

See also

Digital coloring techniques page 22
How to draw chibi mascots page 106

LONGBOARDER
Cruising with Stephen

A student on weekdays and skater on weekends, Stephen prefers to unwind with a scenic ride down the mountain on his trusty longboard, which is larger and sturdier than a skateboard.

Style notes
Skater style tends to be a casual combination of t-shirt, shorts, and sturdy sneakers that have a good grip on the decks. Many will also wear helmets and arm and knee protectors, especially on risky terrain or when attempting tricks.

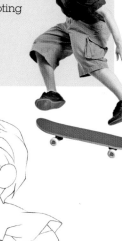

Color Palette
Cool and muted colors create a casual, urban feel, which reflects the nature of this sport. Using dark shades of purple and blue as alternatives to black can give your illustration a more edgy, contemporary feel.

Skin Eyes

Hair and longboard

Shirt and wheels

Shorts

Shoes

Skater poses
A higher head-to-body ratio enables you to create realistic poses (**1**). Showing arms in perspective enhances depth and movement (**2**). If complex poses are too tricky to draw at first, try simplifying the body proportions (**3**).

1 Longboarding is dynamically similar to snowboarding and surfing. The body is balanced on a flat moving surface, with knees bent and arms outstretched to maintain a stable center of gravity.

2 Lilac forms a bridge between warmer pinks and cooler blues, making it a versatile shade for undertones. One advantage of working digitally in Photoshop is that you can use the Hue/Saturation or Color Balance options to fine-tune your palette.

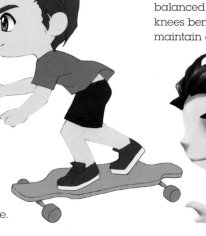

3 Shade the image using a soft-edged brush in Photoshop, giving the illustration a painterly feel. Fabric folds on Stephen's t-shirt create the illusion of speed so he appears to be in motion even without a background or speed-lines.

Style notes
Surf culture has influenced 20th-century popular culture in many ways through its own fashion, music, and slang. Wetsuits, swimming-trunks, and bikinis are integral beachwear, and a golden tan with sun-bleached hair is the result of long hours spent on the beach.

Glenn was a pasty, reclusive Internet junkie before he discovered the joys of riding the waves and adopted the laid-back surfer's life. Now that he has swapped one type of surfing for another he has found a new purpose in life—catching the perfect wave!

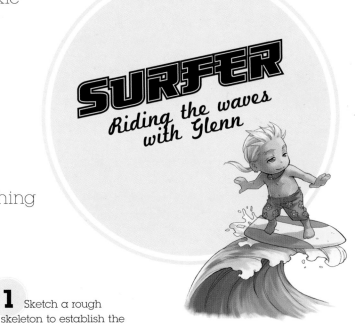

SURFER
Riding the waves with Glenn

Expressions
Something interesting has caught Glenn's eye (**1**). With plenty of pretty ladies strutting about in bikinis, Glenn is likely to fall in love at least a dozen times a day (**2**). After all that exercise, why not take a nap during the hottest hours in the afternoon (**3**)?

1 Sketch a rough skeleton to establish the pose, before penciling and inking the lines. When inking, think about how you can use a few lines to suggest more. Since chibis are simplified characters, the fingers and toes are merely suggested here.

Color Palette

Skin and hair are inherently warm tones, but here the surfboard was also given warm colors to make the character stand out. The green of the shorts is an intermediate color, which bridges the warm and cool colors of the character and background respectively and brings harmony to them.

2 Bright summery hues were chosen for the base colors of the character. The warm yellow and orange stand out against the cool blue of the wave. Choose flat colors that are slightly lighter than the final color that you want, since you will be shading them.

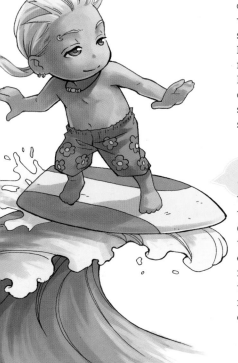

3 When shading, think about which shadows will have hard edges (usually cast shadows) and which ones will have soft edges (usually around rounded forms, such as the cheek or the arm) and make sure there's a variety of both.

See also

How to draw heads, hands, and feet page 28
Digital coloring techniques page 22

Skin

Hair and board Eyes

Shorts Details

Wave

PREPSTER
Jon and Mike say hello

Polo shirts and blazers are wardrobe staples for these two sartorial friends. Working the weekend chic look, Jon and Mike have deliberately gone for some low-key attire that's comfortable for a casual brunch but sleek enough in case there are any pretty girls nearby to impress.

Style notes
Preppy clothes are all about tailoring, combining, and attention to detail. Mixing and matching also creates quirky looks such as a formal blazer and pocket square over a sporty t-shirt and jeans. But everything should be worn for a reason and a sloppy mix of garments is a definite no-no.

See also

How to draw heads, hands, and feet page 28
How to draw clothes page 36

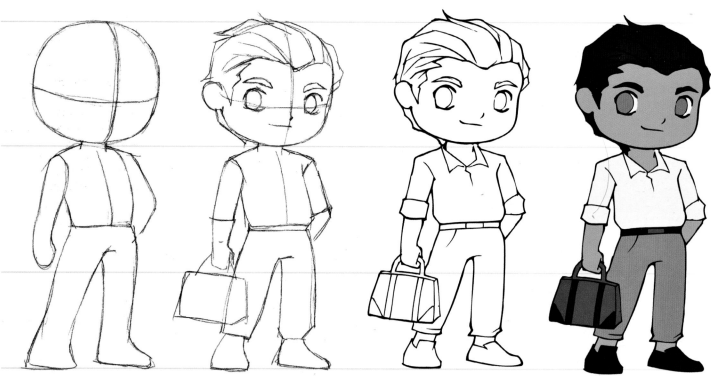

1 This pose is very simple and works for a large variety of characters or situations. You can also play with the proportions and have the head larger or smaller than shown here.

2 Crisply ironed clothes don't have many folds, so you can sketch them in using simple straight lines. Accessories are a great way to balance the composition of an illustration, since they are so flexible in size and design.

3 Varying the line widths when inking makes the image more interesting. Keep smaller details in the hair and clothes thinner and hard edges around the character thicker.

4 Fill in the colors using the Magic Wand tool in Photoshop. The casual shirt and linen trousers generate a lot of gray tones, so the smallest touch of pink and green prevents the image, and Jon's outfit, from looking too bland.

DRAWING A FEDORA

The easiest method of drawing hats on chibi-sized heads is to break the hat down into the simplest shapes that you can visualize, then tweak the angles and details.

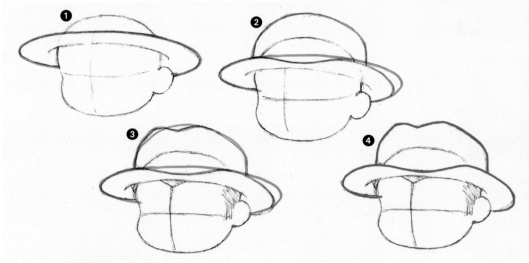

With foreshortened edges and irregular angles, a fedora is probably one of the trickiest accessories to draw. If you can master this, then other headgear designs should be a breeze in comparison! First draw a flat disk around the head (1). Then create a dip on the brim and round off the sides (2). Refine the contours on the top (3). Finally, remove construction lines to clean up the drawing (4).

5 Cel-shade the image using the Polygonal Lasso and then blend the contours together using the Airbrush tool. This mixed shading technique produces a range of sharp and soft edges, making the final effect more realistic.

Mike

Mike's style is slightly more playful and he likes to throw in some unusual accessories, hats, or colored sneakers. This outfit has lighter, fresher colors but still appears classic and tailored.

Color Palette

Classic colors and textures such as cotton, tweed, linen, and denim form the foundations of prepster fashion. These are often accentuated with an unexpected flash of color, such as brightly colored socks or a vivid bow tie.

Skin Hair

Eyes Shirt

Hat and trousers

HIPSTER
Chilling with Anna and Floris

There's no band too obscure and no party too underground for these two urban hipsters. Weekends are spent scouring flea markets for the latest vintage finds followed by attending a trendy music gig with an equally nonconformist crowd. Nobody really knows what job they do, but they're far too cool to reveal that!

Style notes
Clothes are a way of expressing individuality, nonchalance, nostalgia, and social commentary. Vintage glasses can be mixed with unisex shirts, expensive couture, or throwaway fashion. As long as the outfit looks unique and shamelessly trendy, with a touch of subversion, then it's a winner!

Color Palette
Bright colors, logos, prints, and textures are all welcome in hipster fashion. Turquoise, lilac, and pink mix exuberantly with wool, denim, and plain white t-shirts. Makeup can be equally wacky, with self-expression taking precedence over classic conventions.

Skin **Hair**

Lips, glasses, and t-shirt

Blush and shoes

Shorts **Eyes**

Shirt

T-shirt

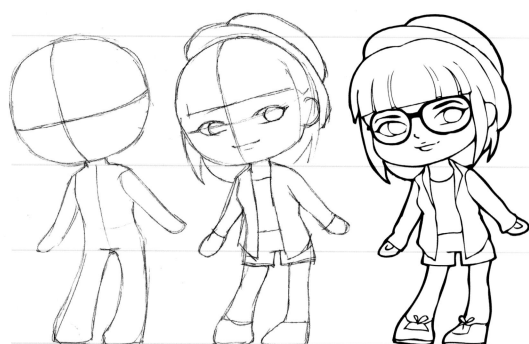

1 This is a simple pose, but the body language still reflects a lot of the chibi's personality. She's leaning forward in a nonchalant way, with head cocked whimsically to the side.

2 As the character will be wearing glasses, it's more convenient if her eyes are drawn narrower at this stage. That way, they won't clash or fill up the glasses frame.

3 Thicker eyebrows on girls make them look tomboyish, and this character was deliberately designed to look quirky instead of pretty in a conventional feminine way.

CREATING REALISTIC ACCESSORIES

It's worth the effort to draw a fashion accessory realistically—start out simply and build the level of detail and angles of curves until you have the right design.

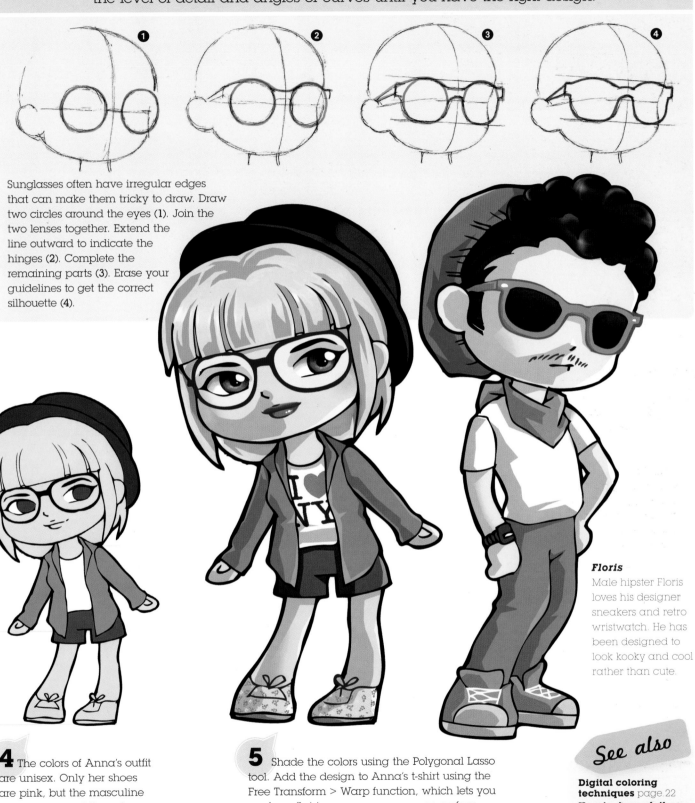

Sunglasses often have irregular edges that can make them tricky to draw. Draw two circles around the eyes (1). Join the two lenses together. Extend the line outward to indicate the hinges (2). Complete the remaining parts (3). Erase your guidelines to get the correct silhouette (4).

Floris
Male hipster Floris loves his designer sneakers and retro wristwatch. He has been designed to look kooky and cool rather than cute.

4 The colors of Anna's outfit are unisex. Only her shoes are pink, but the masculine flat soles prevent them from appearing too girly. Fill in the colors using the Magic Wand tool in Photoshop.

5 Shade the colors using the Polygonal Lasso tool. Add the design to Anna's t-shirt using the Free Transform > Warp function, which lets you render a flat image over an uneven surface, such as fabric.

See also

Digital coloring techniques page 22
How to draw clothes page 36

FASHIONISTA
Front row with Violet

Shopping queen Violet is always the first one working the latest runway trends and has a little black book bulging with details for the most secret designer sample sales.

Style notes

Violet wears a classic little black dress, which works for almost any occasion. She jazzes up her LBD with exotic animal prints and a ladylike clutch purse. Check the latest fashion magazines for inspiration.

Color Palette

The color palette is vivid and varied, with rich jewel-like tones contrasted by sultry blacks and grays. Her makeup is also designed to match her outfit with smokey deep purple eyes balanced by almost nude lips.

Skin **Lips**

Highlights

Hair

Eyes

Shoes

Dress

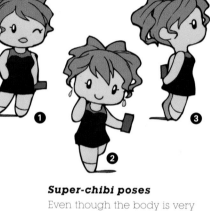

Super-chibi poses

Even though the body is very simplified, the dress is nipped in at the waist to show that it's figure hugging (**1**). Skipping on one foot reinforces Violet's girly side (**2**). In profile, the leg farther away from the viewer can be shaded in a darker color to promote a sense of depth (**3**).

1 Emphasizing the eyes at outline stage is an effective way of making them the focal point of the whole image. For this character, the hands have also been simplified, making them easier to draw.

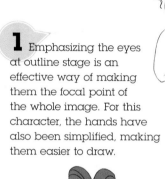

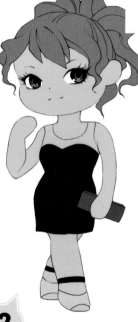

2 Paint in the colors using the Brush tool in Photoshop. Use a warm dark gray for her dress, so it can be shaded later. Because Violet's hair and eyes are so bright, keep the rest of the outfit neutral to bring out the jewel tones.

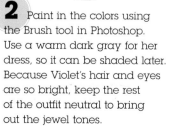

3 Translucent fabric gives the outfit a luxurious and sexy touch. This can be done easily digitally by filling the area with black and lowering the transparency until you have the desired see-through effect. In traditional media, you can use strongly diluted watercolor to build up a translucent wash.

Style notes
Bring out Vienna's bold personality with form-fitting, attention-grabbing clothing. Look to gossip magazines for pictures of celebs out clubbing for inspiration.

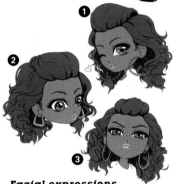

The best place to find Vienna on any evening is in the hippest and most happening clubs in town. Never one to be a retiring wallflower, she lives for any opportunity to show off her sick moves to the latest hip-hop chart-topper.

CLUBBER
On the guest list with Vienna

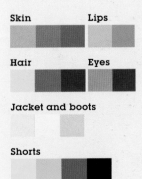

Facial expressions
Showing more whites around the iris can communicate curiosity (2). Raised eyebrows show a more expressive and strong emotion, such as flirtation or surprise (1), and eyebrows slanted in the middle show anger or aggression (3).

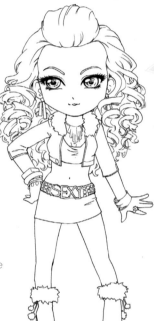

1 Vienna has a strong, confident personality, which is evident through her tilted hip and wide-legged stance. Even at outline stage, you can indicate a variety of textures such as curly bouncy hair, and furry cuffs and collars.

Color Palette
When drawing a bold character, you can go a little more crazy with the color choices and patterns, such as with Vienna's luxurious gold and purple palette. If your character has dark skin, drawing contrasting colored clothes or jewel-studded clothes can bring out the warmth of the skin tone.

2 Add the colors digitally in Photoshop. The predominant tones are purples and honey-toned yellows, which appear glamorous and sexy.

3 Vienna's jacket is creamy white leather but started off with a base tone of lilac. Using contrasting pastel colors for shadow and highlight creates an iridescent surface, which is particularly useful when drawing jewelry or party wear.

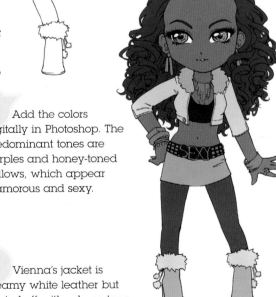

See also

Inking techniques page 12
How to draw and color hair page 32

Skin | Lips
Hair | Eyes
Jacket and boots
Shorts
Tights

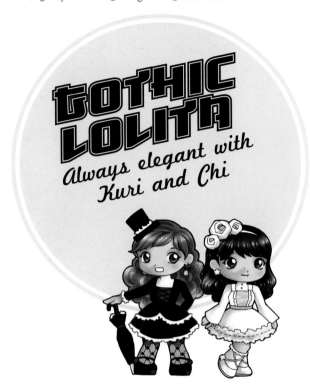

GOTHIC LOLITA

Always elegant with Kuri and Chi

Inspired by historical Victorian and Rococo fashion, Gothic Lolita is an extremely popular style subculture from Japan. Kuri and Chi love the emphasis on elegance, innocence, and ladylike behavior. They often take part in Lolita outings to a park or exhibition, followed by afternoon tea in a beautiful café.

Style notes

There are many subtypes of Gothic Lolita, including kimono-clad wa-Lolitas, grotesque guro-Lolitas, and sweet Lolitas (see page 62). Kuro-Lolitas dress in black and shiro-Lolitas in white. Lolita dresses tend to be nipped in at the waist and flared out to knee length with a frilly petticoat or bloomers underneath.

See also

How to draw clothes page 36
Digital coloring techniques page 22

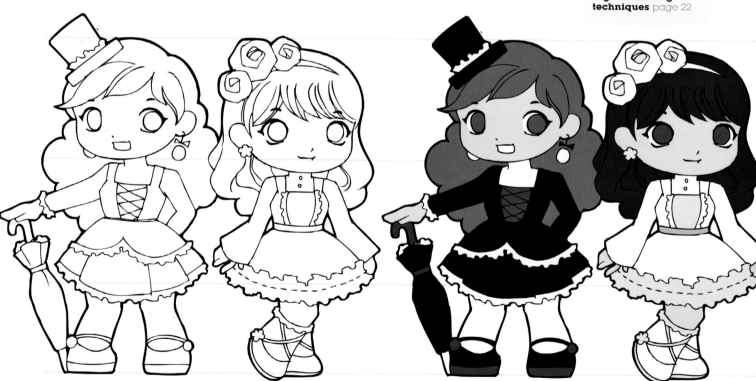

1 When designing Gothic Lolita characters, you can be very generous with lace, ruffles, and ribbons. You can bring an outfit together by using the same lace edging on hair accessories, dress, and socks.

2 The colors will determine what sort of Lolita you're drawing. Pure black and pure white are challenging colors to shade on because they effectively have no lighter or darker counterparts. Use a dark warm gray as highlights for black, and a pale blue for shadows on white.

CHIBI HAIR ACCESSORIES

Chibi headpieces are easier to draw than hats and an effective way to embellish any character design. Gothic Lolita style is known for its wide array of distinctive accessories.

Some of the most popular Gothic Lolita hair decorations include miniature top hats, floral barrettes, vintage bonnets, berets, ruffled headbands, double ribbons (1), a single big bow (2), or frilled caps similar to a maid's headpiece (3).

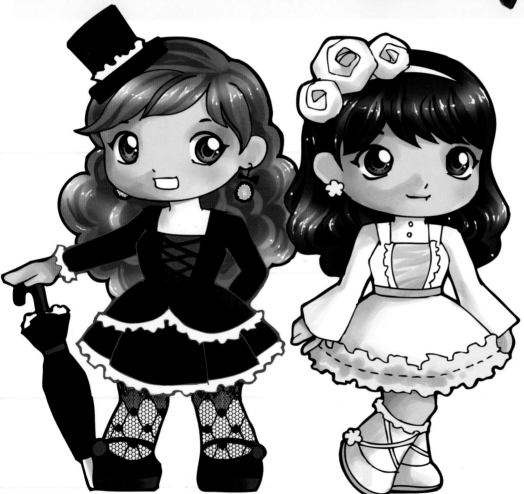

Color Palette

This drawing shows a kuro- and shiro-Lolita, so the palette is monochrome black and white with gentle splashes of color on the hair and eyes. Most Gothic Lolitas steer clear of ostentatious jewelry or bright colors, and prefer cute sugar-almond hues or sophisticated grown-up hues instead.

3 Create visual depth by using different textures, such as lace. The fastest way is to find a stock pattern and paste it over the desired area. This design was originally a bitmap screentone exported from Manga Studio, so it can be used in a color illustration.

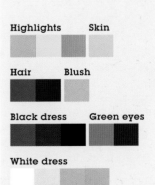

Highlights **Skin**

Hair **Blush**

Black dress **Green eyes**

White dress

Purple eyes

SWEET LOLITA
Join the tea party with Erica

Sweet Lolita Erica adores everything that's cute, pink, and girly. Like a living porcelain doll, she dresses in outfits adorned with bows, ruffles, and kawaii motifs. She sees her clothes as a way of expressing innocence and imagination.

Style notes
Despite the name, Sweet Lolita has nothing to do with the provocative Western connotation of "Lolita." The style is a celebration of cuteness, allowing women of any age to revert back to the childhood delights of dressing up and the elegance of ladylike behavior.

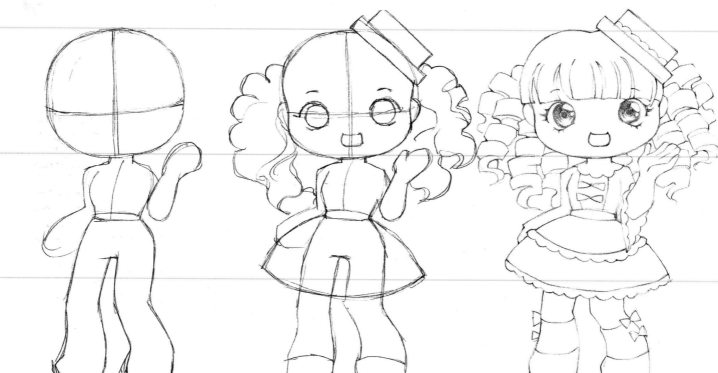

1 Sweet Lolita bodies benefit from having a high waist and short torso, since there's a lot of detail in the skirt, legs, and shoe area. Nipping in the waist early is a convenient way to make drawing the dress easier for the next stage.

2 When drawing the legs, try to make them appear naturally posed rather than two sticks poking out from under the petticoat. The voluminous skirt is balanced by the elaborate hairstyle, which makes the image more exciting than the relatively simple starting pose suggested.

3 This image will be colored using soft pastels, so black ink outlines may appear too harsh. Trace the sketch using a dark brown colored pencil. This highlights the contours just enough for you to see where you're coloring, without overpowering the image.

SUPER CHIBIS

These chibis have a head to body ratio of roughly 1:1, making them particularly cute and expressive. They are easy to draw, but make sure that the outfits are simplified correctly.

Sweet Lolita dresses bisect the body, so the puff of her skirt should be visible even on a very basic proportion (1). When she is sitting down, the skirt shape changes but volume remains consistent (2). A walking pose is more dynamic when only one leg is shown (3).

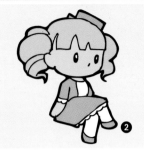
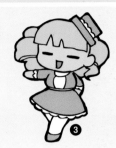

Traditional coloring techniques page 18
How to draw clothes page 36

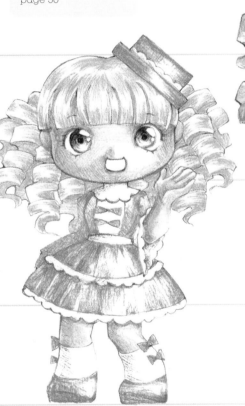

Color Palette This palette is inspired by cupcakes and candy, making it perfect for a Sweet Lolita! Pastels don't clash and can be mixed with each other, so you can also experiment with baby blue, aqua, peach, or mint green for cute color schemes.

4 Apply the soft pastel in sketchy strokes and layer a few shades on top of each other to create depth. Use gentle crosshatching to create transitions and make sure you leave out any areas that need to remain white.

5 Blend the colors together with your finger or cotton swabs. If you do make a mistake, lift off some pigment using a soft pencil eraser. As a finishing touch, use the brown pencil to emphasize edges and detail.

Skin **Eyes**

Hair

Dress and accessories

Lace **Outline**

Reiko is into ganguro fashion, a rebellious street style among Japanese youngsters. Ganguro girls deliberately defy traditional Japanese notions of beauty, such as pale skin and dark hair, opting instead for a bleached blonde Californian look, tanned skin, and outrageous outfits.

Style notes

Ganguro style is characterized by dark skin, light hair, hibiscus flowers, vivid neon or rainbow colors, false lashes, sticker crystals, plus multitudes of beaded, dangly costume jewelry. Girls will also often apply light makeup around their eyes and on the bridge of the nose, creating a panda-like impression.

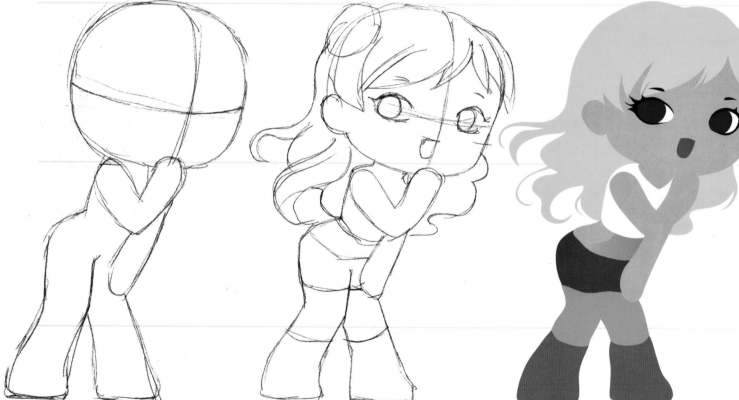

1 When creating poses, try to make sure that important details aren't obscured. Here, Reiko's right arm is lifted so you can still see her belly-baring outfit underneath. Because she's leaning forward, her torso needs to be slightly foreshortened so the limbs can be positioned naturally.

2 Volume and foreshortening can be emphasized further in this step by using clothes. After drawing in Reiko's shirt and shorts, it's more evident that her body is leaning toward the viewer at an angle.

3 Scan the sketch and open it in Adobe Illustrator. To color artwork in Illustrator, create new layers and draw vector shapes using the Pencil or Pen tool. You'll notice that each shape is defined by small "Anchor Points," and you can adjust the edges by clicking on anchor points with the Direct Selection Arrow.

FACIAL EXPRESSIONS

Ganguro girls are spirited, cute, and cheeky, so you can let your imagination run free with fun expressions.

A passerby might glance disapprovingly at Reiko's outfit, but she's used to it (1)! Ganguro girls love pale lipstick that contrasts with their tanned skin (2). You can draw long hair in such a way that you don't need to show collars or shoulders, which may come in useful if you ever want to use the character's face as a stand-alone icon or mascot (3).

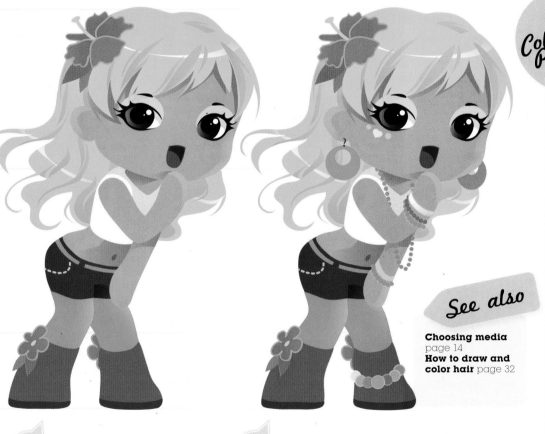

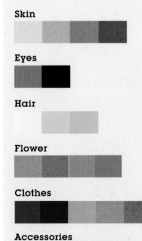

Color Palette

Hot pink, lime green, and bright yellow and rainbow beads... anything goes in Ganguro land! Bright colors stand out against tanned skin so summery clothing and accessories are particularly popular. Pure white is also a popular tone for shoes or accessories.

See also

Choosing media page 14
How to draw and color hair page 32

4 Add shading by drawing more vector shapes filled with subtle gradients, shadows, or highlights. To keep track of everything, you can "Group" shapes together so you don't end up with hundreds of layers. Crisp shapes and dotted lines provide the perfect finishing touch to the image.

5 To create beaded necklaces and other decorations in Illustrator, draw a regular path and give it a stroke (outline) and no fill. In the Stroke menu, choose Round Cap, Dotted Line, set Dash to 0pt and Gap to anything slightly higher than your stroke width. If you want to expand the dots, choose Object > Flatten Transparency.

Skin

Eyes

Hair

Flower

Clothes

Accessories

Kigurumin full-body animal pajama suits are popular among trendy girls looking for a comfortable and cute yet shocking new style. On weekends girls like Peach and Koko run around Tokyo in groups, looking like a sparkly set of little pets!

Style notes

Kigurumin often overlaps with Ganguro style, with girls choosing to maintain tanned skin, dyed hair, and multiple accessories. Kigurumin suits are designed so that the legs are very short, giving the impression of a super-cute round body. Soft and fleecy, they come in all designs, including hamster, frog, bear, cat, and video-game creatures.

Animal poses

Since they are pajamas, any time feels right for a snooze (**1**). You can build a Kigurumin body using oval shapes (**2**). The body form resembles an animal mascot more closely than a human chibi (**3**).

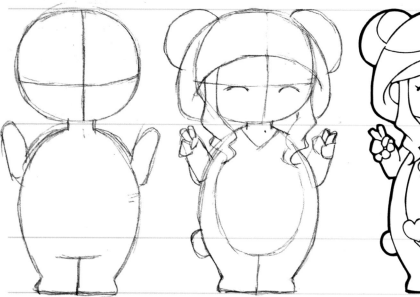
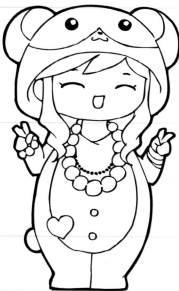
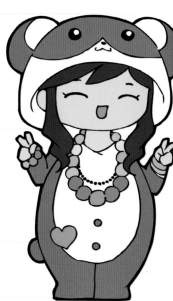

1 Draw an egg shape as the base for the Kigurumin body. This gives the chibi a portly, round silhouette, making it appear all the cuter. Since there will be a hood as well, the cross denoting the face is positioned slightly lower down.

2 Now draw Peach's hood and hair over her head, using the guidelines to position them correctly. Whenever there are many layers of detail involved, make sure that both sides of your character remain roughly symmetrical.

3 There are effectively two faces in a Kigurumin chibi, which is why it packs a double punch of cuteness! Peach's eyes are closed here, so her hamster hood has open eyes by contrast.

4 Fill in the colors using the Magic Wand tool in Photoshop. Rainbow colors immediately give any image a carefree feel and are great for emphasizing childlike characters. Chunky jewelry also makes the body appear smaller and more petite.

KIGURUMIN ANIMAL HOODS

Kigurumin hoods can be adapted for any kind of creature. You just need to adjust the color, ears, mouth, and nose to create a brand new species.

A bear has small round ears and a visible muzzle (1). Pigs have curly ears and a distinctive snout (2). Cats can be a variety of colors with trademark pointy ears (3). This bunny has tiny eyelashes to make her look more feminine (4).

Color Palette

This palette is bright and cheerful, exactly like the chibi Kigurumin girls! Warm browns and grays evoke the fluffy feel of the animal suits and rainbow accessories make the outfit fresh and fun. As long as you use all the colors evenly, a rainbow spectrum can fit into any color scheme.

Koko
Koko wears a koala kigurumin made out of gray fleece, complete with a pouch where she can stash her makeup.

5 Use the Polygonal Lasso to create this typical manga cel-shading style, with bold colors, crisp edges, and black outlines. Choosing the right tones for your shadows and highlights makes all the difference. Here, a very gentle transition was used on Peach's face and tummy to indicate volume without overpowering the image.

See also

How to draw chibi animals page 40
Digital coloring techniques page 22

Skin

Fur suit

Hair

Mouth

Beads and accessories

Beads

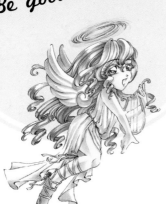

Ciel is a bright, shining being from the heavens. Shimmering with love and laughter, she plucks at her harp and sings in crystalline tones as she flits by.

Style notes

Ciel's dress is made of flowing cloth held in place by ties or belts, reminiscent of religious paintings and Grecian costumes. Her long, loose, curly locks look playful but pretty. Her wing design is cute, rather than realistic.

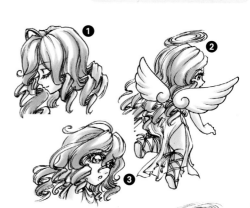

Angelic poses and expressions

Ciel will most likely be smiling beatifically (**1**), or concerned for someone (**3**). She is often in an aerial pose with her robes and hair fluttering about her (**2**).

Color Palette

Ciel's overall look is pale but warm, creating a shimmery, iridescent feel. All the white cloth is shaded in tones of blue and light gray. The tones of gold are consistent throughout the image to tie it together. The hair has four shades—including the white of the paper—for maximum shine.

1 Ink your sketch carefully with marker-proof pens. When inking, keep a delicate touch and leave gaps to make Ciel look more ethereal. Use smooth motions for the waves and curves.

2 Color in larger or paler sections first. Markers are similar to watercolors in use—they just dry faster and look smoother—so start with the pale colors for safety.

3 Color the smaller details or higher contrast areas. More levels of shading give a shinier feel to the surface. A subtle backlight was created on Ciel's wings by blending the dark blue shadow into a cooler, lighter gray.

Skin

Dress and wings

Halo and gold

Hair

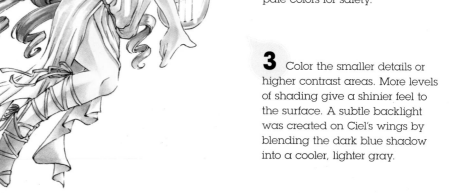

Style notes

Terra dresses like a commanding demoness in a dominatrix-inspired bodysuit with vampish boots. The skulls on her kneecaps and the cape add to the fear factor. She has bull's horns and a pointed tail. Her pitchfork is a great spearing tool.

Terra is a mischievous demon who is working her way up the underworld. She dresses a little more self-importantly than she should, but thinks the cape makes her look more intimidating.

1 Sketch in pencil. Don't press too hard, since you will need to erase this later. Weight Terra's pose naturally to the side to give her pride in her stance and allow the cape to flow. When inking, vary your line widths and give heavier weighting to objects closer to the viewer for a 3D look. Make sure her spiky hair has sharp, tapered tips.

Although Terra has tanned skin, she has a cool color palette. Her black leathers have tinges of blue and lavender. The reds are magenta-toned and her striking silver hair has an otherworldly feel.

Demonic expressions

Terra can switch instantly from maniacal laughter (**1**) to a suspicious stare (**2**) to a stubborn pout when she doesn't get her way (**3**).

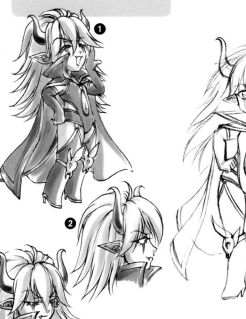

2 Fill in the larger sections first with alcohol-based markers. These evaporate slower than water-based markers and enable you to create blended colors. Be careful, since dark colors that bleed over the lines can't be covered up.

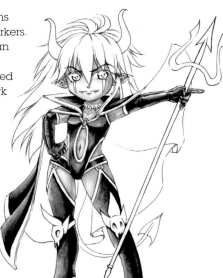

3 Color the smaller details or higher contrast areas. Wait for the markers to dry if you want the shadows to look sharp. Alternatively, you can work while the ink is still wet to get a soft, blended feel.

See also

Traditional media tips page 16
Traditional coloring techniques page 18

Skin		

Horns, tail	Hair

Eyes	Cape

Leather	Skulls

KING
Evil King John

His majesty is a grumpy Scrooge who loves nothing better than to plot world domination, and think of new ways to squeeze more taxes out of his poor subjects. When no one is around, he sneaks into his treasury to roll around in his hoard of gold coins.

Style notes

The clothes that King John is wearing are loosely based on Tudor royal fashion. Reach into the past for inspiration in designing the look of your royal subject, even if you're designing a fantastical futuristic king. Royal clothing of the past is often characterized by rich, heavy fabrics, such as velvet, decorated and embroidered with fancy patterns.

Royal emotions

The king's temperament can change from a gleeful smile (**1**) to scheming smirk (**2**) in the blink of an eye. But needless to say, he's happiest when dreaming about all the riches in his kingdom (**3**).

Color Palette

Using a dark black and red costume palette gives King John a more sinister and evil air. Golden details add to the dark opulence of his royal clothing. Contrast the dark and warm palette of the clothes with the light and cool tones of his skin and hair.

Skin

Hair

Eyes **Fur collar**

Cape **Tunic**

Gold

Jewels **Embroidery**

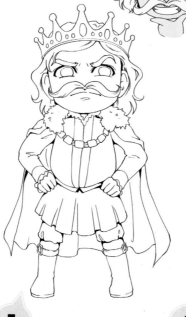

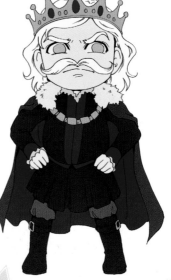

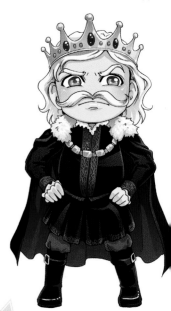

1 Think of your drawing in terms of 3D shapes, and plan the way the clothing and accessories sit in relation to the character's body. Lines of clothes and objects rarely appear as straight lines on the body, and tend to curve around the body as concave or convex lines depending on the angle of the body.

2 Block in the main colors you want to use on the various sections of the drawing. Here a monotonous, uniformly dark outfit gives King John a more sinister and unfriendly air.

3 Once you're happy with the flat colors, start putting in the deeper shadows and brighter highlights. The King's robe is made out of rich brocade fabric, which you can replicate by using golden embroidery and warm gradients.

Style notes

Marie is dressed very formally for an important function. She has a ballgown embellished with ruffles and pearls. Her shoes are also very dainty. She wears a tiara rather than a crown and her hair is partly done up, since she is still young.

Princess Marie is regal, dainty, and calm. She considers every word she says, as she knows how important it is to keep up appearances. She is the picture of elegance and femininity as she enters the ballroom.

PRINCESS
Dance with Princess Marie

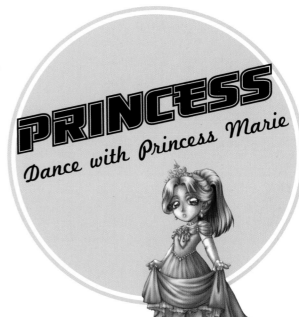

Regal expressions

Marie's serene expression makes it look like nothing could ruffle her feathers (**1**). She is always poised and collected (**2**). Thin eyebrows and detailed eyelashes make Marie look elegant even with her eyes closed (**3**).

1 Outline your sketch using a black mechanical pencil, which allows a small amount of shading. Outlining in pencil isn't a common technique but is effective if you work cleanly so the lines don't smear. Add shading and texture, then scan and tint in sepia.

2 Put in a gradient under the line-art. For a beautiful, magical sense of lighting, use pink tones fading into purples and blues. Start working in the basic colors directly on the gradient layer. Use a semitransparent soft brush to pick up the underlying hues well. Make the colors lighter and more opaque nearer the light source.

3 Add stronger highlights and shadows as needed to increase the contrast. Work a glowing yellow into the highlights and a cooler violet-indigo into the shading.

Color Palette

A rose-tinted palette dominates here, flitting from cool to warm tones, depending on the lighting. Marie's pale skin and strawberry blond hair shine in the light and fade into warm peaches and russets. Her celadon green gown has brilliant yellow tones in highlight, and rose and lilac in shadow.

Skin Highlight

Hair Shadow

Dress Rose

Petticoat Shoes

Gloves Tiara

See also

Digital media tips
page 20
How to draw clothes
page 36

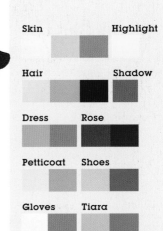

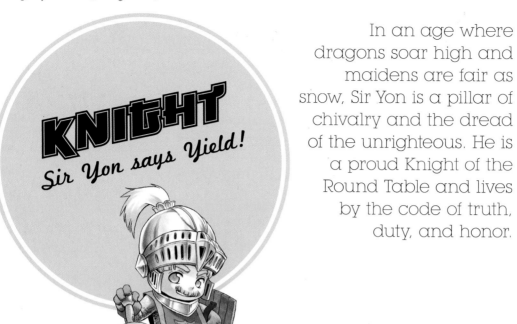

KNIGHT
Sir Yon says Yield!

In an age where dragons soar high and maidens are fair as snow, Sir Yon is a pillar of chivalry and the dread of the unrighteous. He is a proud Knight of the Round Table and lives by the code of truth, duty, and honor.

Style notes
Knights are based in medieval history, so there's a wealth of information on the dress and customs of the time. A suit of armor consists of many pieces, but when drawn on a chibi body it is necessary to be selective and avoid overcrowding the drawing. Think of what makes for an interesting design.

See also

Traditional media tips page 16
Traditional coloring techniques page 18

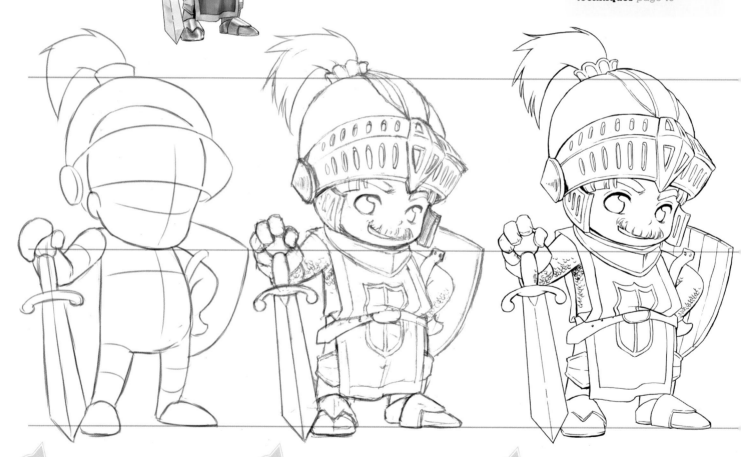

1 Start by building the body and the major elements of the drawing with basic shapes. Draw crosshairs on the face and the upper body to show the direction in which the character is turning.

2 Build on the skeleton drawing and add more detail. Pay attention to how cloth and plates of armor overlap and describe this carefully.

3 Ink the outlines of the pencil drawing. The texture of the chainmail and little details are more easily described at this stage than at the coloring stage.

Color Palette

The strongest colors in the palette are gold, green, and sky blue. The rest are muted earth shades or cool gray. The blue and the green are cool colors that match, and the warm gold acts as a contrast. It is a good idea not to use too many strong colors, since they clash more easily.

Skin

Hair

Surcoat

Shield, gloves, and belt

Armor

Color accent

USING DETAILS FOR EXPRESSION

Use the mustache and the plume of the helmet to enhance expression and movement.

For stern expressions, it's important to show eyebrows (1). Experiencing a fleeting moment of doubt as the opponent comes galloping toward him (2). Drawing the head tilted upward conveys arrogance (3).

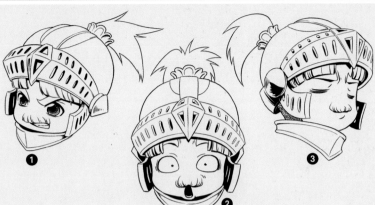

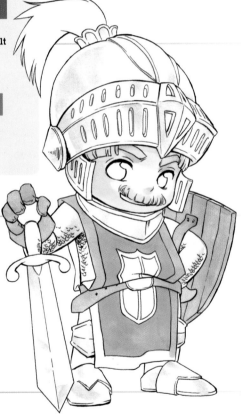

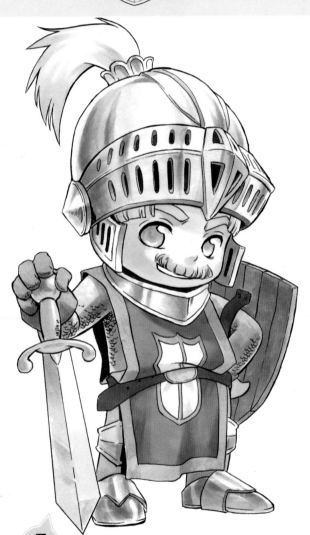

4 When using alcohol-based markers, start with the lightest colors and gradually work your way toward the darker shades. Use the white of the paper to describe highlights.

5 When shading, try using a different color than a darker shade of the base color. The blue shade on the green surcoat gives the material a shimmering effect. To describe metal, put the brightest highlight close to the darkest shadow. Look at photos of metal surfaces for reference.

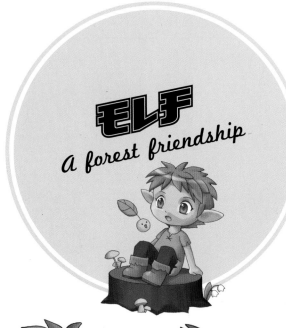

ELF
a forest friendship

Pip is a tree elf living in a hidden village with woodland sprites. On New Moon nights, the forest creatures dance across the meadows and leave behind fairy rings of pink mushrooms.

Style notes

Pip wears elven garb in shades of moss green and soft leather. They blend perfectly into a dappled forest clearing, and humans are never quick enough to spot them. Forest elves are playful and innocent, preferring clothes that are simply cut and unhemmed.

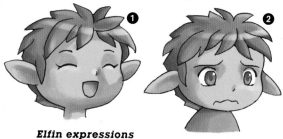

Elfin expressions

Even if they're male, elves are impish and cheeky so you can get away with some cute expressions. Look for ways you can use the ears to express emotions, such as perking up (**1**) or drooping down (**2**).

1 Sketching a chibi sitting pose can be tricky because it involves a lot of leg bending, which results in a tendency to elongate limbs. Try to keep an eye on perspective when drawing. This was inked using a dip ink pen with a Maru nib. This gives you a super-thin line and nicely reflects the delicate feel of the image.

Color Palette

The color palette is inspired by afternoon sunshine in a forest glade, with warm golden highlights on green leaves and brown bark. The slightest touch of pink gives the image a cute visual depth.

Skin

Highlights **Hair and boots**

Eyes and tunic **Pants**

Mouth

2 Colors and shading were done using the Brush tool in Photoshop. Working with a gentle palette means you don't need to do any strong shading, just the slight indication of volume is enough.

3 A quick way to soften up an image is to tint the outlines brown/sepia. Without the use of pure black, the picture appears gentler and calmer.

Style notes

Fairy dresses are floaty and romantic, like layers of translucent flower petals. Fairies are petite so they can wear short skirts and fitted tops, often adorned with real blossoms, berries, and leaves. Mica's hair is voluminous and shiny—she swears by sleeping on a pillow made of spider silk!

Meet Mica: a sparkly, glamorous flower fairy. With skin the color of chestnuts, she's got her share of admirers among the forest elves, but Mica herself only has eyes for a human boy who saved her once during a hailstorm.

FAIRY
Mica's magic dust

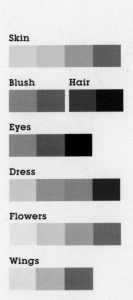

1 A simple way to keep an image visually pleasing is to repeat similar shapes. Mica's hair, magic wand, hands, and head are circles, and her ears, wings, and flower decorations are leaf-shaped. Scan your sketch, then ink in Photoshop, so that you can zoom in to get thin, crisp lines.

2 Paint in the colors using the Brush tool in Photoshop. Working on lighter hues makes the shading process easier, and you can use the Levels function to boost the contrast and saturation.

Fairy poses

Flying characters don't need a center of gravity, so you can come up with creative poses (**1**). Simple foreshortening of one arm makes Mica appear as if she's in motion (**2**). Perched on a leaf, Mica's wings are nicely visible in this pose (**3**).

Color Palette

The color scheme is vivid and rich, with deep browns contrasted by bright highlights. Hot pink and lime green is a visually pleasing combination and can be used to spice up any palette. When drawing fantasy creatures, you can get creative with eye color, such as the deep purple here.

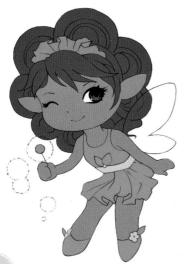

3 Dropping in tiny white highlights is particularly effective in bringing out the shine of Mica's hair. Fairies are ethereal creatures, so you can experiment with shiny and sparkly surfaces. To create her wings, fill in the outline with a blue gradient and then reduce the transparency to 50 percent for a see-through look.

Skin

Blush **Hair**

Eyes

Dress

Flowers

Wings

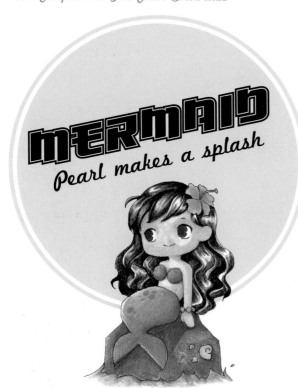

Mermaid Pearl lives on a little tropical island and swims around rock pools, tanning and collecting shells. She is quite shy but curious and will often observe human ships from afar. The few times sailors have caught a glimpse of her tail fin, they weren't sure whether it was the legendary mermaid, or simply the result of one too many rums on deck.

Style notes
A mermaid's tail is iridescent, making it ideal for using green, turquoise, blue, and pink shades. It's easy to render reflections and sparkle in these colors by adding small flecks of the other shades as highlights. Accessories should be natural materials such as blossoms, shells, and coral.

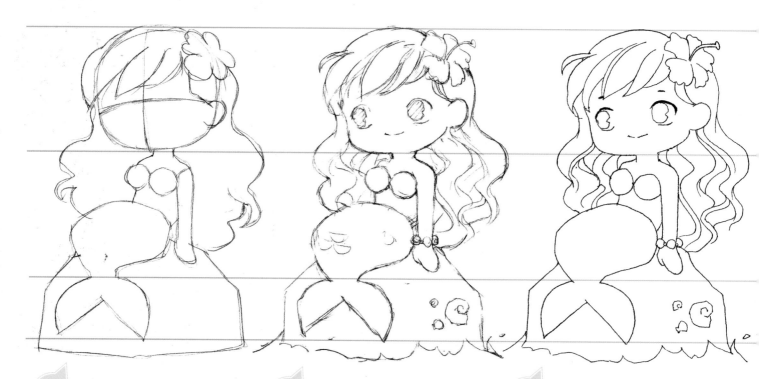

1 Start off by deciding the position of the head and torso. The tail can either be sketched freehand, or you can visualize a chibi sitting with both legs together. Even though the lower body is unusual, remember to keep the head–body ratio consistent.

2 When coloring traditionally, you should always work large. Use a full sheet of paper for your chibi so you have enough room to draw and shade. Even on a simple image such as this, there's still space for little details, such as fossils and beads.

3 Ink your sketch using a manga nib pen. This will be painted with watercolor in the next step. When using wet media, always check that your black ink is waterproof. Test this by drawing a few lines on scrap paper and rubbing a few drops of water over them to see if the ink smears.

Color Palette

The neutral grays and blacks serve as a backdrop to make the brighter greens and pinks really pop out. This image was colored using natural media, and you'll find that mixing pencil over watercolor can really enhance the color saturation.

Skin

Rock

Eyes Flower

Tail Water

See also

Traditional media tips page 16
Traditional coloring techniques page 18

POSES

Similar to the Fairy (see page 75), Pearl doesn't have a center of gravity when swimming, so you can be very creative with poses.

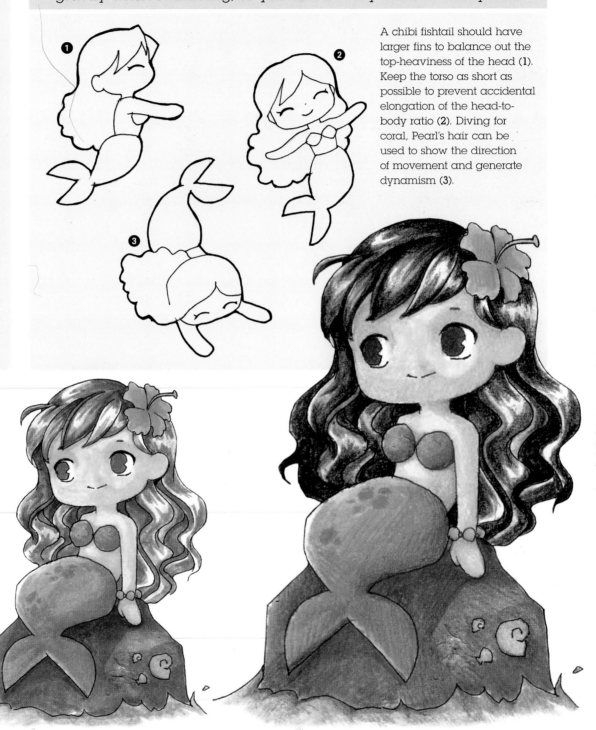

A chibi fishtail should have larger fins to balance out the top-heaviness of the head (1). Keep the torso as short as possible to prevent accidental elongation of the head-to-body ratio (2). Diving for coral, Pearl's hair can be used to show the direction of movement and generate dynamism (3).

4 Now paint the first layer with watercolor, taking care to preserve white space where there are highlights. Leave Pearl's eyes blank for a gentle, retro feel. The watercolor will provide a perfect, slightly gritty surface for colored pencils. Let everything dry completely before proceeding.

5 Lastly, use colored pencils to build up color intensity and blend out any uneven shading. Two layers of pigment will really make the emerald green of Pearl's tail pop out. The same goes for her hair. It's much easier to create a silky effect using black pencil than black watercolor.

WITCH

Wanda says "Woohoo!"

Well above the wild wastelands, Wanda the Witch whooshes by on her trusty broomstick. Daring and adventurous, nothing beats a moonlight ride for this witch with a wicked affinity for speed. If only Billy the Cat shared his mistress' worship of wind.

Style notes
The old lady with the pointy hat, black cat, broomstick, and warts on her nose is the well-known description for the Western witch. But rather than working by the book, you can create a more interesting witch by changing a few elements, such as adding unusual colors and accessories.

Color Palette

The magenta and purple of Wanda's dress are feminine colors that suit her character. The silvery hair is shaded using pale blue, which is muted enough not to clash with other colors. Her green eyes stand out, since there is no other green in her outfit, but it is echoed in the green tinge of the broom.

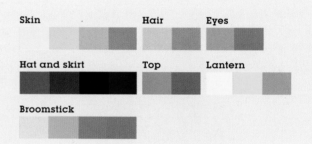

Skin Hair Eyes

Hat and skirt Top Lantern

Broomstick

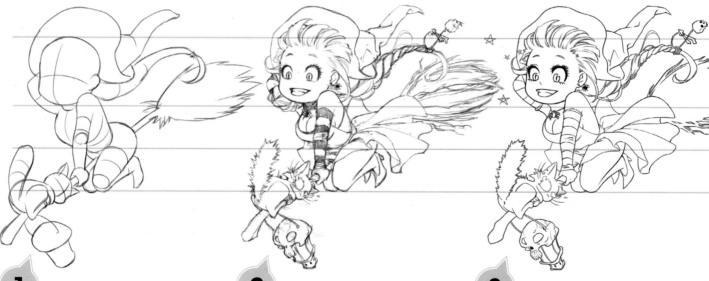

1 When drawing characters interacting with props, take extra care with the points of interaction. Draw the broomstick first and use it as a guideline to position Wanda's hand and body.

2 In the detailed drawing, pay attention to the silhouette of the entire illustration, including broom and lantern. A silhouette that is easy to read creates a stronger design.

3 When inking the drawing, leave out some of the details, such the individual bristles in Wanda's broom. These will be painted later during the coloring process. Make sure that there are no gaps in your outlines. This makes it much easier to select specific areas to be color-filled.

DETAILS AND EXPRESSIONS

Mischievous characters are particularly fun to create expressions for. Make sure any accessories, such as Wanda's hat here, correspond with the angle of the face.

The "cat mouth" is often used in manga illustration to suggest a cute and cheeky expression (1). Visual grammar such as sparkles can be used when Wanda is casting a magical spell (2). Hands are very expressive tools, so combine those with facial expressions to communicate ideas more clearly (3).

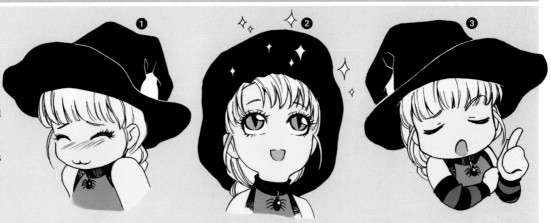

See also

Digital media tips page 20
Showing emotions page 34

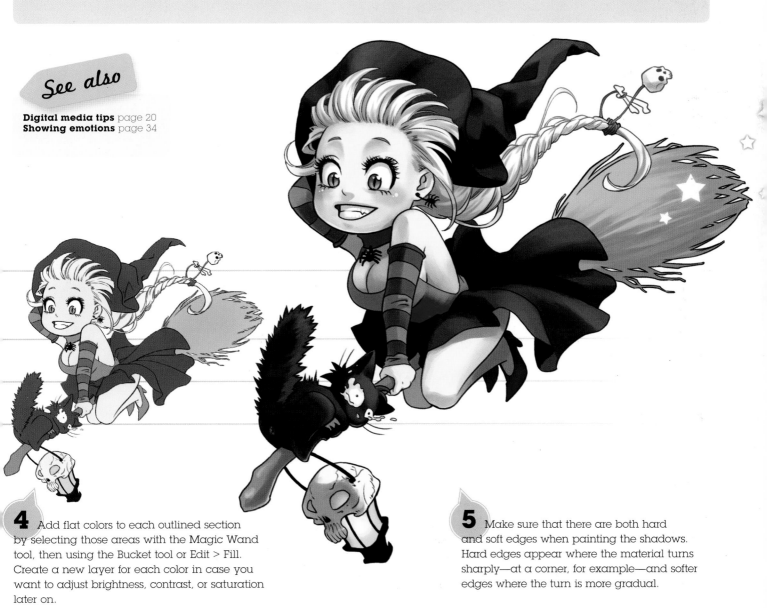

4 Add flat colors to each outlined section by selecting those areas with the Magic Wand tool, then using the Bucket tool or Edit > Fill. Create a new layer for each color in case you want to adjust brightness, contrast, or saturation later on.

5 Make sure that there are both hard and soft edges when painting the shadows. Hard edges appear where the material turns sharply—at a corner, for example—and softer edges where the turn is more gradual.

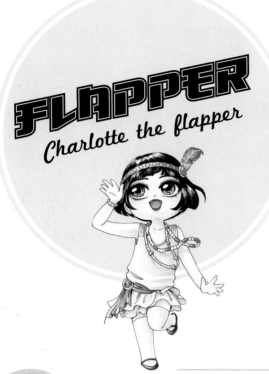

FLAPPER
Charlotte the flapper

It's the Roaring Twenties, a time of economic boom and budding liberalism. A generation of bold young women eager to throw off the yokes of "proper acceptable behavior" are emerging. Charlotte loves nothing better than to have a good time dancing the night away in the trendiest flapper fashion.

Style notes

The flapper look favors short bobbed hair and bold makeup on a slim, boyish figure. Dresses are usually quite straight and tight, with arms bare. Add ropes of art deco-inspired bead necklaces, brooches, and rings, and you're good to go. Don't forget the iconic dark dramatic makeup.

Color Palette

Use soft, warm pastel colors to bring out the feminine aspect of the character, and cooler purples for the shadows. Jewel tones, such as bright green and gold, are used for the accent jewelry.

Skin

Hair

Eye makeup

Eyes

Dress

Accessories

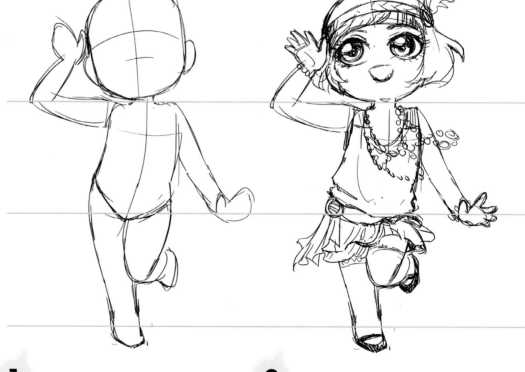

1 Prep your character by working out her pose and blocking in the basic body shape. Choosing a pose that fits the personality of your character adds extra depth to the artwork. Sometimes breaking away from formal "model" poses and instead drawing your chibi in an action pose can bring more life and expression to your character.

2 Add in details, such as the swing of Charlotte's bead necklaces and the flip of her flirty skirt. Flapper dresses can be quite plain, relying on the short, floaty skirt to allow greater ease of movement when dancing. Spice up the attire with 1920s-style feathered headbands and bracelets.

CAPTURING CHARACTER

Bring your chibis to life by creating a "character sheet" showing typical poses and expressions. Draw them from different angles to present a realistic impression.

Charlotte is very expressive (1) and doesn't feel the need to be reserved and ladylike (2), so draw her with different animated expressions (3), (4). She isn't shy about reapplying her makeup in public, and can smoulder with the best of the screen sirens (5).

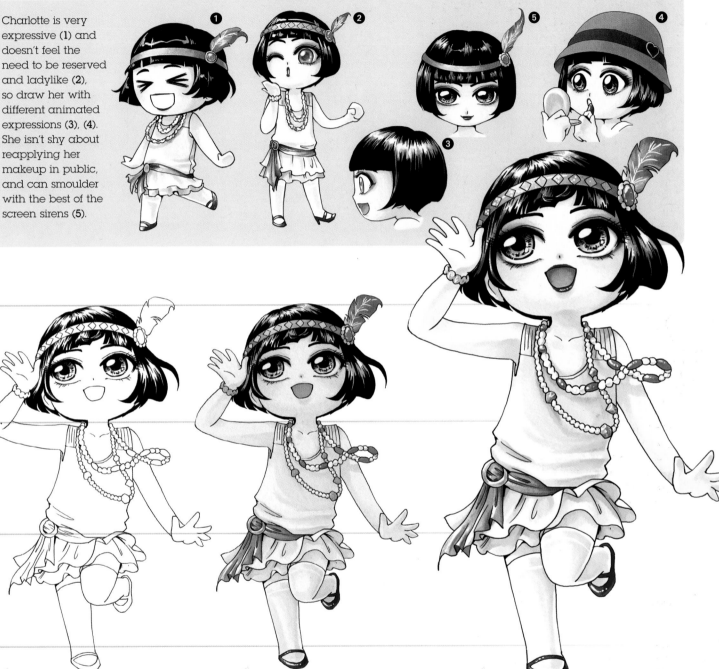

3 Ink your character using pens, brushes, or digital media. Here, dark brown ink was used instead of black to soften the look in preparation for watercolor. Sepia outlines add a warmer, slightly more retro feel to the image.

4 Using light washes of color, carefully shade in the basic form and solid blocks of color. Gradually build up the intensity of pigment as necessary. Flapper dresses traditionally tended to be in classic shades, such as cream, beige, white, navy blue, or black. However, you could try adding a bold, modern twist and experimenting with bright colors.

5 Using darker, slightly cooler colors, paint in the darker shadows to make your image pop out more. Use a mix of hard edges and softer, well-blended edges in your colors to bring more definition to your image.

A member of a magician family, William's distinguishing features are bunny ears and a black crystal heart that harnesses special powers. His parents have disappeared under mysterious circumstances so he is taken care of by his older siblings. All of them know a dark magic that could be used to create chaos, but also good deeds.

Style notes
The Gothic Lolita outfit is based on historical children's clothing and embellished with ruffles, lace, and embroidery. The jewelry is often made from delicately forged metals and precious stones. Symbols such as the cross, batwings, or Jass—a medieval card game—are also frequently seen. *Alice in Wonderland* is a classic literary source for Gothic Lolita imagery.

See also

Traditional media tips page 16
Traditional coloring techniques page 18

Color Palette

Dark palettes such as black, violet, and maroon are popular in Gothic Lolita images. This is particularly effective when contrasted with pale, ethereal skin and hair.

Skin

Hair

Bunny ears

Eyes

Clothes

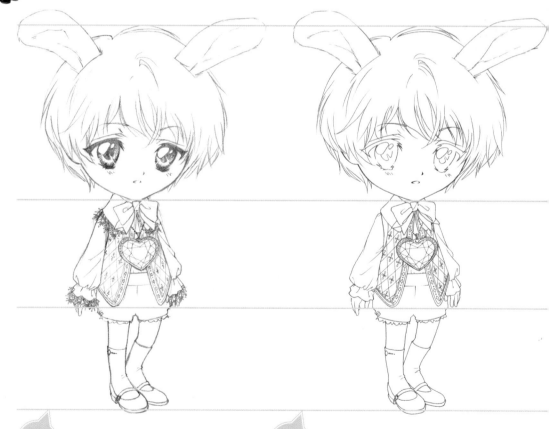

1 Sketch on a large sheet of paper to give you space to create far more detail on the chibi character. Add intricate embellishments in clothing and accessories, which will be inked in the next step.

2 The paper used here is Bristol board with a very smooth surface. This won't absorb pigment as quickly and makes blending colors easier. Ink the sketch with a sepia-toned fineliner, which fits much better with the delicate subject.

CHIBI HEADS AND TORSOS

Being able to visualize a chibi body in two component parts makes it easier to construct more flexible poses.

An effective way of drawing chibis is to start off with the relative positions of head and torso. Picture the head as a large apple and the body as a small avocado (1). By moving these elements around you can create a variety of poses and dynamics.

The shoulders are thin and delicate, which enhances the cuteness of the character. The top part of the torso is tapered inward and will be filled up once you add the arms (2). Guidelines help you determine the angle of the face (3).

Imagine the body as a puppet with a string down the middle that lets you swivel the separate elements about. After you have your desired pose, add hair and clothing on top. For an extra kawaii body, make the arms and legs short and nonintrusive (4).

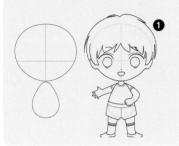
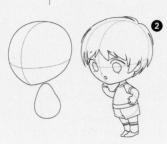
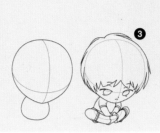

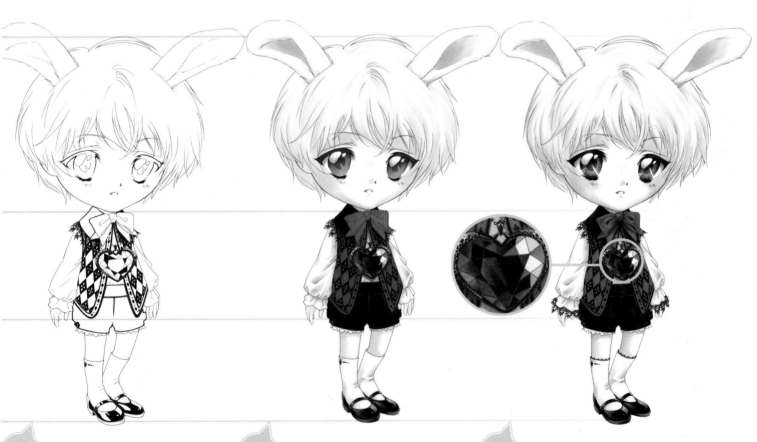

3 Ink in the black detailing. This gives the final image a lot of depth and will allow even the smallest details to stand out. Apply the black ink inside the brown lines, so both hues are visible.

4 Color the image with alcohol-based markers. To create soft shadows, first apply the lighter shade followed by the darker shade, and then use the lighter marker to blend the boundaries where the two colors meet. This needs to happen quickly before the ink dries, so hold both markers at the same time without lids so you can switch rapidly between the two.

5 Use colored pencils to create shadow and texture, and to give the image more volume. Apply small amounts of white ink or pencil to the darker areas to create an immediate shiny, reflective effect. Add fine details to the hair, crystal heart, and lacy sleeves.

Swifter than a striking adder, his katana flashes through the dark. Ren's blade is known to be the deadliest in all of Japan. Warlords clamor for his loyalty, but to no avail. Nomadic and masterless, the sword-slinging samurai stands alone, offering his blade only to those whose cause he deems worthy.

Style notes
There are a range of elements that can be used to characterize the Japanese samurai. The high ponytail, the baggy pants (hakama), the overlapping shirt (gi), and the split-toe sandals (geta) all call to mind ancient Japan. For more elements, look up photos of Japan's dress and armor.

Intense postures
When Ren holds his sword suspended, this pose suggests his readiness to spring into action (**1**). The traditional way of sitting in Japan, where the legs are tucked under the body, is called "seiza" and is often used in meditation (**2**).

1 When you draw the outfit, manage the folds and other elements in a way that creates an interesting silhouette, with a variety of jagged and straight sections. Close gaps between lines so that you can use the Magic Wand tool to save time when filling in colors.

2 Drop the areas of color in using the Magic Wand tool, then paint the edge of Ren's sword with the Brush and Eraser to suggest speed and blurriness. Broken outlines or color are great for showing movement.

3 Ren's face is shrouded in shadow, making him appear more ominous. Shade with a hard-edged brush with a touch of the Dodge tool for highlights. This creates a typical anime cel-shading effect.

Color Palette The color palette is mostly muted, cool, and dark, with a sprinkle of bright red, which hints at blood and death.

Skin · Hair · Shirt · Hakama · Vest · Sword

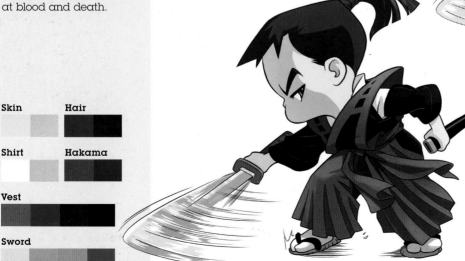

See also
Digital coloring techniques page 22
How to draw clothes page 36

Style notes

Ninjas are traditionally portrayed in black outfits, which aid their covert infiltration and espionage work. They also have concealed weapons that are light and easy to carry, and are experts in martial arts. Real-life historical ninjas were like the secret agents of their day, and were often disguised in everyday outfits such as samurai clothing.

Living in 15th-century Japan on Honshu Island, Tanzo Tanaka is one of the finest ninjas! He is as deadly with his katana sword as he is throwing hira-shuriken stars. Cool and silent at all times, he disappears into the shadows until his target has no way to escape!

NINJA
Tanzo Tanaka, the master of stealth

1 Starting with the line-art, Tanzo's pose is dynamic and full of motion. Fill distant areas with black to enhance the depth. You can balance a composition with accessories, such as the trailing headband, which nicely fills up the empty space under his arm.

2 Change the color of your line-art by selecting the layer option "Lock Transparent Pixels" and filling the whole layer with a desired shade. Purple outlines go nicely with the red hair and stand out against the skin tone.

3 Now it's time to add the shading. Rather than using black, try a dark purple. This helps the shadows blend into the line-art. Add a thin white contour in the opposite direction of the main light source to give the image a dramatic backlit effect.

Ninja poses

Showing angular edges under Tanzo's chin and foot enhances the volume and makes it easier to draw dynamic poses (**1**). A "puff" of visual grammar is used to show surliness (**2**). A billowing scarf balances out the composition (**3**).

Color Palette Working with a limited palette makes an image look more sophisticated and stylized. If the colors are analogous, you can use the same tone to shade all areas. In this case, the purple is dark and rich enough to be used for all the shadows and gives the image a unified look.

See also

Digital media tips page 20
Digital coloring techniques page 22

Skin Highlight

Hair Shoes, belt, and robe

Metal Shading

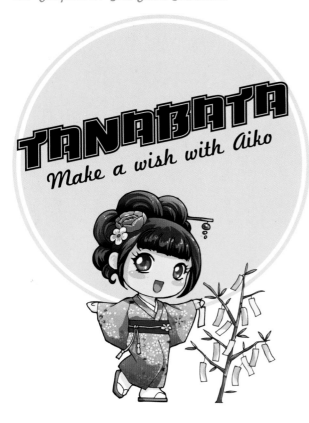

TANABATA
Make a wish with Aiko

As a blossoming young girl, Aiko is all excited to dress up in her favorite yukata to attend the Tanabata festival with her friends. Her mom lent her a jade hair pin to decorate her updo. She's got some important wishes written out on a slip of paper to hang on the bamboo tree (mostly pertaining to doing well in her exams, and being noticed by that boy she likes).

Style notes
Yukatas, a less formal version of the kimono, are worn by young girls and are usually brightly colored with elaborate patterns all over. When drawing culture-specific clothing, remember to do some research so you don't commit an accidental fashion faux pas. For example, both the kimono and yukata are always worn left collar/lapel over the right. Wearing it the other way around is for funerals!

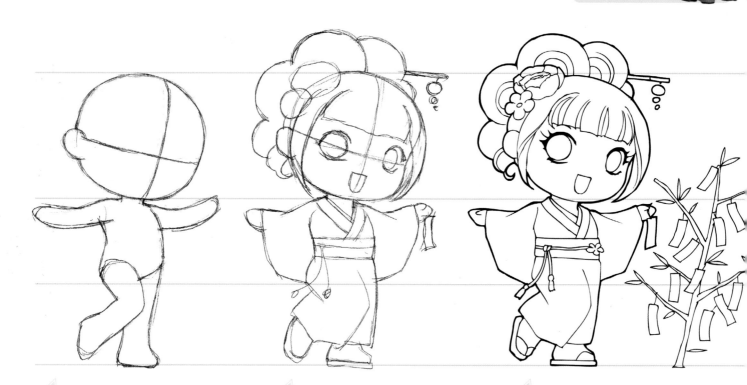

1 Restrictive dresses, such as yukatas or pencil skirts, prevent a character from active poses, such as running or leaping. Bear this in mind when sketching your base pose so it will complement the clothing later on.

2 Yukata sleeves have a bat-wing shape so they are much easier to sketch in if you have guidelines for the arms in place. The neck is considered a tantalizing body part in traditional Japanese culture, and is often revealed in pinned-up hairstyles like this one.

3 When inking the yukata, it's often more effective to leave the main areas blank instead of trying to draw in a complex pattern yourself. There are endless online resources for fabric motifs that will save you a lot of time and energy.

Color Palette

Yukatas are often colorful with bold and bright patterns. Using colors inspired by nature and flowers gives the character a fresh, happy feel.

Skin

Hair

Shoes

Yukata

Bamboo tree

Slips of paper

TRADITIONAL CLOTHING AND MODERN GIRLS

Yukatas are still popular with girls in Japan today and they often jazz things up with modern makeup and hairstyles.

When drawing super-deformed chibis like Aiko's friends here, leave out elaborate details to focus the eye on the simplicity of the shape, texture, and facial expression (1). Yukatas and kimonos wrap around the body, so start with a cylindrical shape bisected around two-thirds up by the obi belt (2). Accessories include pretty pins in the hair, little purses that dangle from the wrist, or paper fans (3).

See also

How to draw clothes
page 36
Digital coloring techniques page 22

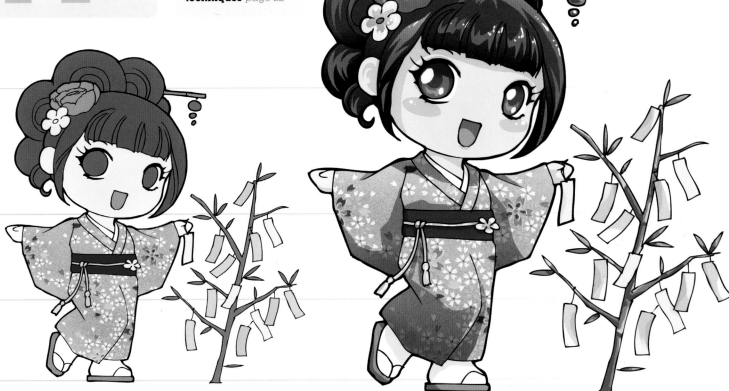

4 You can use cute origami paper to create the fabric design. Find the patterns online and insert them into your drawing via imaging programs like Photoshop. Make sure you use designs with copyright permission. Or if you're feeling crafty, cut and paste the paper into a collage over your image.

5 Adding some subtle shading over the design completes the three-dimensional effect. If working digitally, create a "Multiply" layer over the fabric pattern and paint your shadows. This layer effect allows you to see through the colors and is great for adding tints without obscuring anything underneath.

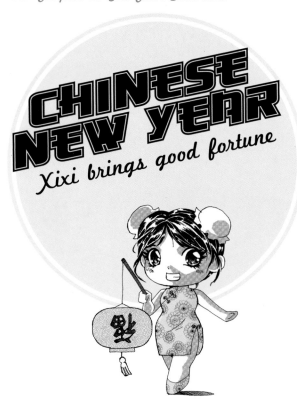

CHINESE NEW YEAR
Xixi brings good fortune

Xixi (pronounced "ShiShi") studies biology in Beijing and is excited to go back to her hometown for the Lunar New Year. She'll be joining a big family party with food, candy, firecrackers, and the much-anticipated "red envelopes" of money that are given to all younger family members.

Style notes

The traditional Chinese qipao or cheongsam is made out of satin with detailed embroidery. Xixi's qipao is decorated with chrysanthemum flowers, which are a symbol of good fortune in Chinese culture. Instead of buttons, the qipao has twisted rope ties. Xixi carries a red lantern, another color associated with happiness and prosperity.

See also

Digital media tips page 20
Using chibis in manga page 110

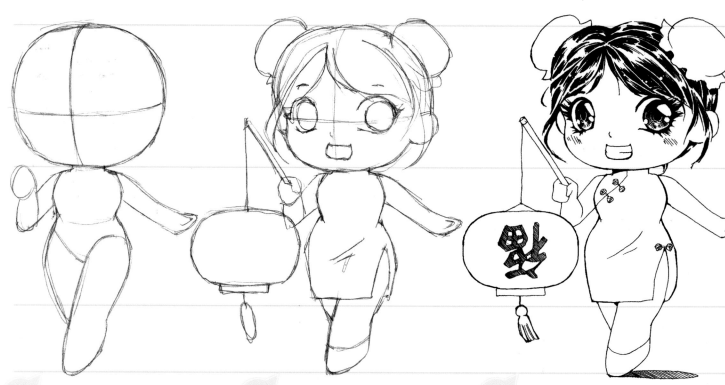

1 Create the character using simple shapes. As the outfit is very fitted, it's useful to define the silhouette at this stage. When drawing chibis, the torso should always be as short as possible, which helps maintain the super-deformed proportions.

2 Add a lantern to balance out the composition. Even though the pose is simple, planning out intricate areas of detail, such as the Chinese character, the hair, and the eyes, keeps it visually appealing.

3 Ink the image with a dip ink pen and Maru nib for very fine lines. Especially for the hair, it's important to work slowly and delicately, leaving out areas that need to remain white.

EXPRESSIONS

When working in black and white, aim to do most of the detailing at the inking stage, such as coloring in the hair or eye highlights.

Cheek blush can be depicted with gently hatched lines instead of color. This is Xixi's expression when checking that the dumplings are cooking (1). A chibi face is round and flat so the nose doesn't always need to be shown on the profile view. Instead, some blush over the nose instead of the cheeks gives it a cute contour (2). Screentone shading can be used to give the impression of a nose without outlining it in black (3).

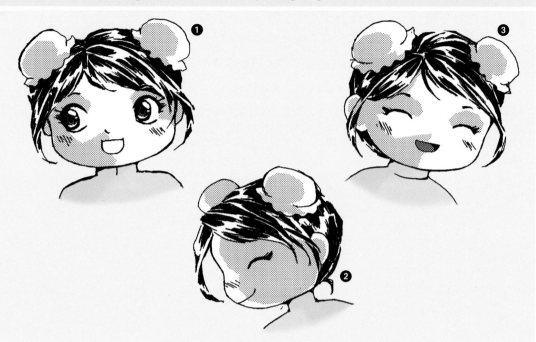

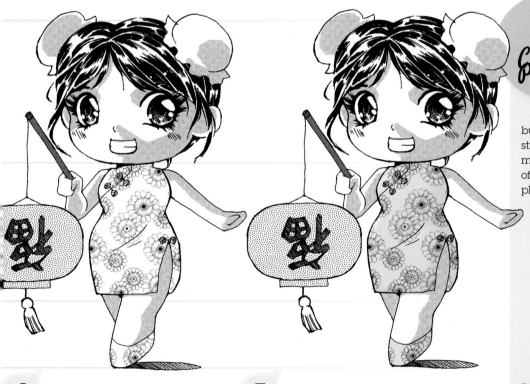

Color Palette This image has a special palette, since it was created using screentone. This is commonly used for black-and-white manga pages, but the effect can also be very striking in color illustration. A monochrome image with a touch of color is reminiscent of vintage photographs and evokes nostalgia.

4 Screentone emulates different shades of gray by using black dots, which enables manga comics to be printed using black ink only. Special patterned screentone was used to create the fabric design on Xixi's dress and texture on her lamp.

5 Adding color is an unconventional step for a screentone illustration, but in this case, the slightest touch of pink makes the image pop out. Similarly, you can experiment with screentone patterns in full-color images for more unique looks.

Dress

Screentone shading

Ink

OKTOBERFEST
Celebrate with Ann-Kathrin

Ann-Kathrin is 17 and lives in the pretty state of Bavaria in southern Germany. She can't wait to attend the Oktoberfest, a giant annual festival that attracts visitors from all over the world. She's excited to try on her dirndl dress and hit the food stands for some giant pretzels!

Style notes

The dirndl is a Bavarian and Austrian dress that women wear to Oktoberfest. The apron bow is traditionally used to symbolize marital status; when worn on the right it indicates the woman is married and when worn on the left, it means she's single. Other dirndl elements include a bodice and puff-sleeved blouse, and braided hair.

Color Palette

The palette is mostly neutral and warm, evoking a nostalgic, Germanic feel. The golden tones are also reminiscent of beer, the most iconic beverage served at Oktoberfest!

Skin **Hair**

Dress and pinafore

Blouse and socks

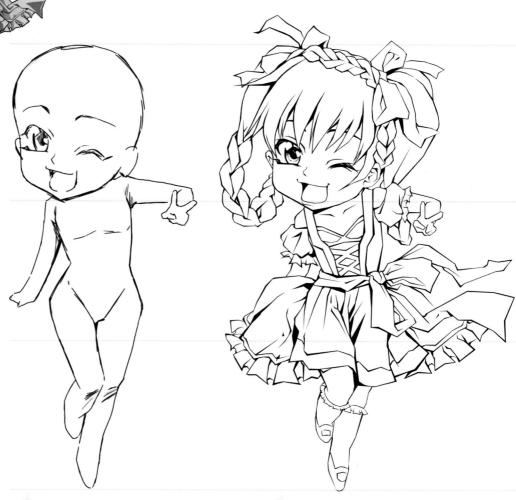

1 First sketch out the body to decide on the pose and check that there aren't any mistakes in the anatomy and proportion. Always draw clothing on top of the body instead of sketching an outfit right away.

2 Now you can draw the dress and hair, and ink all the details. Make the line width thicker at any place where there is shadow to give a sense of depth. When drawing many fabric folds, try to keep all lines crisp and separate instead of using hatching or rough strokes.

COMPLEX HAIRSTYLES

If you create a complex hairstyle, practice drawing it from all angles. This "spin around" view is typically used when designing manga characters.

Ann-Kathrin has one braid pinned across the front of her head like a hairband (1). The side view shows that her pigtails are also braided near the ends (2). Both pigtails can be left hanging loose or pinned in a loop, as shown on the main image below (3).

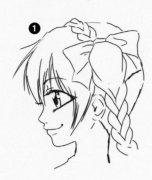 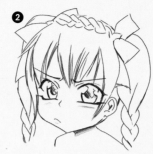 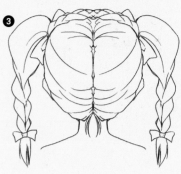

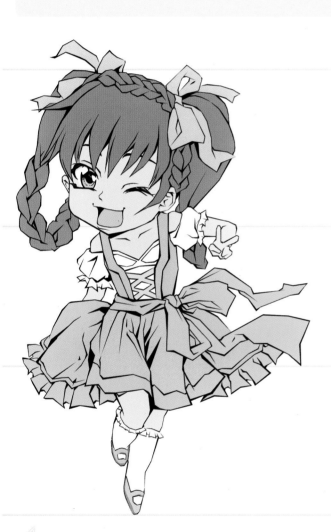 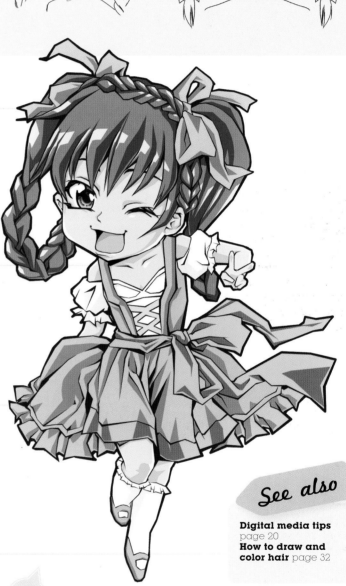

See also

Digital media tips
page 20
How to draw and color hair page 32

3 Solid ink outlines make it easier to select areas using the Magic Wand tool and fill in the colors. A blue accent shade contrasts nicely with the creamy neutral beige of Ann-Kathrin's skin, dress, and hair.

4 Color the illustration in sharp cel-shading style using the Polygonal Lasso, which complements the angular inking style and minimalist palette. Add highlights to the hair to change the texture and give the image a 3D quality.

FOURTH OF JULY
Bro out with Flip

"Work hard, play hard" is the motto for frat boys, so when the holidays roll around, hedonism is the headline. Flip is gearing up for the Independence Day barbeque with all his fraternity brothers. They have the food, drinks, and fireworks. Flip's in charge of the music and he knows his awesome DJ skills will keep the party people dancing 'til dawn.

Style notes
American university style is a mix of casual chic with preppy pieces, such as jeans and flip-flops teamed with polo or rugby shirts. These can be accessorized with baseball caps, leather belts, and designer sunglasses, or sheepskin boots and purses for the girls. Check out famous clothing brand websites for inspiration and outfit references.

See also

Inking techniques page 12
How to draw clothes page 36

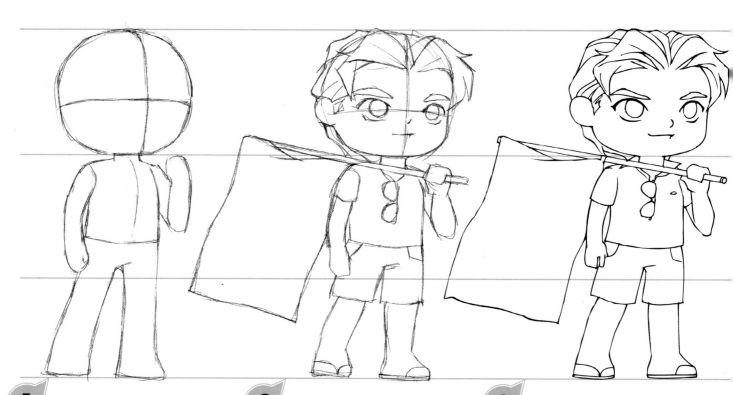

1 The pose is simple but leaning upward in a patriotic fashion. Use curved lines on the face and chest to create this effect. Even at this basic stage, decide on the body language and in which direction the character is looking.

2 Sketch in details, including hair, features, and clothing. Adding a large flag balances out the composition and gives the image a striking focal point. Don't be afraid to exaggerate for chibi illustrations!

3 Details on flags or fabric should be left out of the inking stage, because giving them too much definition can be unnecessarily distracting. But keep in mind what patterns you want to give the image later on.

EXPRESSIONS

When drawing a young character you can try out a range of expressive faces, such as cheeky, drunk, cheerful, bored, angry, or sleepy.

Flip has an infectiously cheerful personality, so try out a wide grin with closed eyes (1). If drawing thicker eyebrows, match the color to the hair but do not give it any shading (2). Visual grammar of bubbles can be used to indicate tipsiness. Flip's feeling the effect of that keg stand (3).

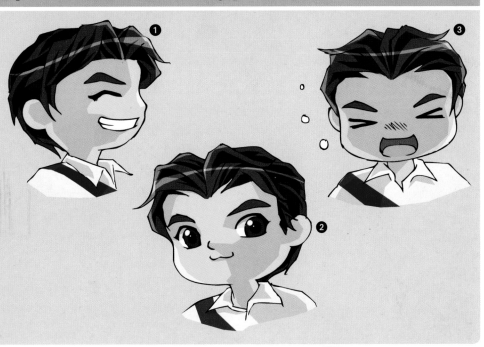

Color Palette

As befitting a national holiday, this palette reflects the American flag. The basic red, white, and blue can be expanded into teal, maroon, and gray for a greater range of color. The smallest touch of yellow gives the image warmth and vibrancy.

4 When depicting stripes on fabric, make the lines slightly wobbly instead of identically parallel for an easy and effective way to create the impression of folds. This works for flags, shirts, bags, and all.

5 As a finishing touch, a flat grid of stars was pasted into Photoshop and edited using the Free Transform tool. The Skew function allows you to stretch it into the correct perspective and the Warp function distorts the surface to match with the fabric folds underneath.

Skin

Hair **Highlights**

Shorts and flag **Shirt and flag**

Shirt and flag

SANTA
Festive cheer from Yule Winterberry

Being born on Christmas Day hasn't dampened Yule's passion for the festive season! He always spends his birthday dragging around his sack of presents for his family and friends. His favorite birthday gift is white chocolate—luckily everyone knows this, so he is never in short supply!

Style notes

Originally, Saint Nicholas, the person upon whom the present-day Santa is based, was tall and thin and wore bishop's robes! It was in the 19th century that the jolly bearded Santa became one of the most famous symbols for Christmas. Although his outfit has evolved into the iconic red-and-white robe, Saint Nicholas' gift-giving tradition has certainly remained!

Color Palette

The shading in this illustration has a blue hue, for example, the shading on pink parts like the face is presented as purple rather than dark pink. This overall blue tone gives the picture a wintery feeling. Try using other colors to "tint" your shadows and see what feeling it gives your picture.

Skin	Eyes		Clothes	Boots	Sack

Parcels			Hair and fur trim

1 Draw a rough sketch of Yule Winterberry using basic shapes. Use guidelines around the middle of the circle of the head and in the middle of the bottom of the circle and the chin to place the eyebrows and mouth.

2 Using the shapes from the previous step, sketch in the clothes and details. In this case, the hands have been left as circles to add to the "cute" look—but you may prefer to draw the hands fully on your chibi.

3 Ink the image digitally using the Pen tool in Photoshop. Notice how the fur trims on Yule's hat and clothes have not been outlined because soft objects have less noticeable edges.

FESTIVE EXPRESSIONS

Try pulling your face in a mirror and see what shapes your mouth and eyes make. Then emphasize those shapes to give your chibi even more emotion.

A puff of air emphasizes grumpiness. Maybe it's because Yule's sack feels a lot heavier this year (**1**). Flipped up eyebrows indicate alarm, and you can draw them over the hair if necessary (**2**). With his deliveries done, Yule is very pleased with himself! Exaggerated rosy cheeks are often used to make chibis even cuter (**3**).

See also

Digital coloring techniques page 22
How to draw the body page 26

4 Paint in the fur trims using a soft-edged brush to make them appear extra-fluffy. Fill the rest of the colors in using the Magic Wand tool.

5 Add shadows with the Polygonal Lasso and Brush tool. Using a light blue to shade the white areas will make them look clean and crisp, just like freshly fallen Christmas snow!

In the thickest forests of northern Sweden, there's a honey farm run by two friendly bears. Bror and his brother Sven decided to go into beekeeping after realizing they lacked the killer instinct of most grizzlies. Bear honey is said to be delicious because the bees feast on wildflowers during magical midsummer days when the sun never sets.

Style notes

Despite their large size, brown bears have a naturally kawaii look. They tend to be very round and very furry, with small ears and expressive poses. Bears love salmon, honey, nuts, and berries, and gorge on these to build up fat reserves for hibernation. Female grizzly bears will become super aggressive toward anyone who threatens their cubs.

Color Palette

To break up the monotony of having a single fur color, the stomach area can be made into a lighter shade. In this case, yellow is used to complement brown and enhance the sense of volume.

See also

How to draw chibi animals page 40
Digital coloring techniques page 22

Highlights **Outline**

Fur

Tongue

Jar

Honey

Wooden honey spoon

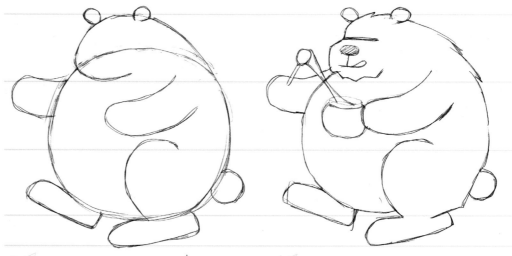

1 When drawing any round and fat animal, start with a circle and build up detail around it. Add the bear's head to the basic shape to create an egg-shaped silhouette.

2 Add props to emphasize Bror's occupation. As you may not always have the option of drawing clothes, props are useful in creating defining features for your animal.

BEAR CLANS

Create different species of bears by starting with the same body shape and changing the size and color.

Pandas are small, tame, and lazy with distinctive markings (1). They are mostly vegetarian, and live alone in bamboo forests. Black bears share a similar habitat to brown bears, but are comparatively less aggressive (2). Polar bears are the largest and most dangerous bears of all. They survive in Arctic conditions and hunt seals for food (3).

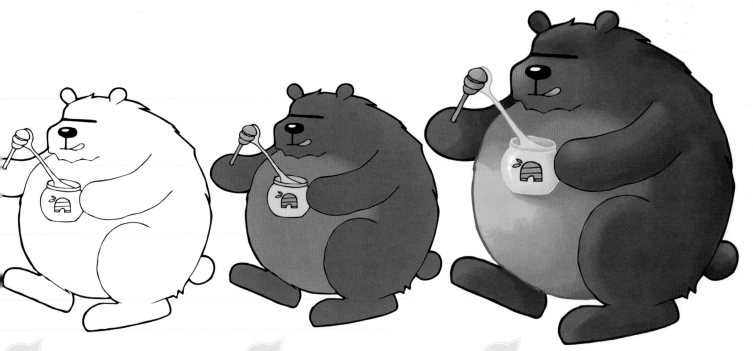

3 Ink the sketch by hand and then scan it in. For optimal visual balance, use thin lines where there is a lot of detail, such as the honey pot, and thicker lines where there is less detail, such as Bror's back and legs.

4 Add the colors using the Magic Wand tool. Use the Brush tool to create a soft transition between Bror's stomach and body fur. Most animals have a lighter stomach area, which can be useful for creating visual variation.

5 Shade in a painterly style using a medium-edged brush. The key to painting large round bodies is to keep blending the colors until every contour fades smoothly into the next.

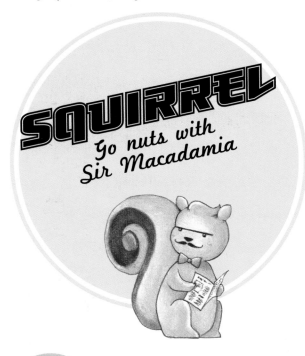

SQUIRREL
Go nuts with Sir Macadamia

Plenty of squirrels like to frolic on the university campus in fall, and the oldest and wisest among them is Sir Macadamia. A renowned professor of Nutology, he gives lectures on the best hiding places and tastiest nut trees. In his free time, Sir Macadamia enjoys poetry, opera, and other intellectual pursuits.

Style notes

Squirrel species are gray, red, black, brown, beige, and white. If you're designing a group of squirrels, it's more fun to give them very distinct colors and appearances, rather than present them as a uniform group of animals. For an exotic twist, look up momongas, which are incredibly cute Japanese tree squirrels.

Color Palette

Mixing brown with beige creates an appealing palette for squirrel fur. Depending on which species of squirrel you're drawing, you might want to try gray, black, or cinnamon colors. Bright accessories give the character a unique and humorous appeal, both visually and conceptually.

Main body fur

Highlights

Tail fur

Bow tie **Blush**

Expressive tails

Squirrel tails can be used effectively to express emotion. Draw the tail drooping downward for sadness (**1**), pointing upward for happiness (**2**), or straight out for caution (**3**).

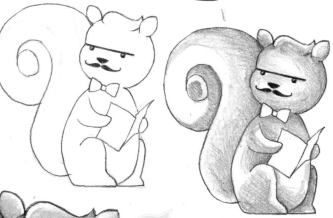

1 As with any traditional media piece, start by working large. Outline your sketch in dark brown colored pencil. The body language gives this character a dignified and thoughtful edge.

2 Apply the first layer of color using soft pastels with a gentle crosshatching technique. It's important to leave all the pigment dust on the paper for blending, so don't shake or blow the sheet.

3 Fingertips are ideal for blending the pastels together because you can control the pressure and there's a bit of natural moisture on your skin that sets the pigment into the paper.

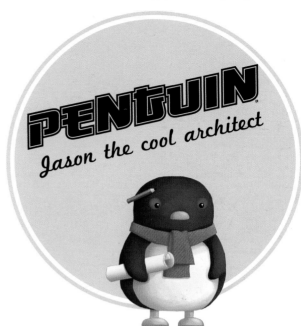

PENGUIN
Jason the cool architect

Style notes
Penguins are perfect characters to draw in chibi style because they have a simple body shape, amusing mannerisms, and distinct body markings. They're also docile yet mysterious, making them fascinating animals to develop for fiction. Penguin chicks have pale, downy feathers with speckled markings.

From his hometown in Antarctica to the skylines of New York City, Jason is a celebrated designer with the international jet set. Asked about his inspiration, Jason simply says: "The time I spent inside an egg had a profound effect on how I visualize space. And I want to share this with others."

Penguin species
King and Emperor penguins are the biggest species (**1**). Adelie penguins are very social (**2**). Macaroni penguins have brightly colored tufts over their eyes (**3**). Fairy penguins have a unique blue tinge to their feathers (**4**).

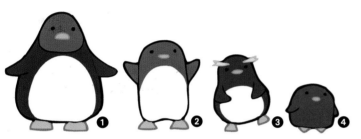

Color Palette

The penguin is one of the few animals where it would be appropriate to use a cooler palette. Blues, grays, black, and white create a sophisticated color scheme. Some penguin species have a splash of bright yellow or orange, which is a natural way to include some beautiful contrast in the image.

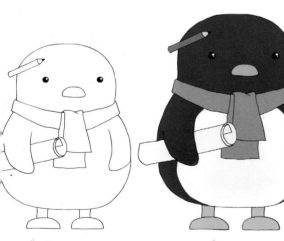

1 There's no specific guide for animal bodies, so start by doodling various designs to loosen up your drawing style. Choose the shape that appeals to you most. Scan your sketch and then ink it digitally in Photoshop.

2 Use very light tints instead of pure white to make your image more interesting to look at. Jason's stomach is pale lilac and the blueprints are pale cyan, which are warm and cool variations of the main blue tone.

3 Apply the colors and shadows using the Brush tool. Creating realistic shading on a relatively unrealistic character enhances the comic effect. Drawing thin, hard shadows under objects such as the blueprint and scarf improves the sense of depth.

Tummy Eyes
Beak and feet
Body
Scarf
Blueprints
Pencil

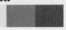

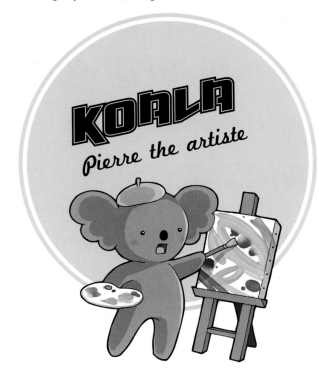

Quite how Pierre came to Paris is a mystery, but he lives a reclusive existence in an attic painting abstract pictures of leaves. Despite a cult following for Koalart, Pierre struggles to earn a living and get his work into the galleries of Saint Germain. So he continues to endure life as a misunderstood genius, fueled by red wine and eucalyptus-flavored macaroons.

Style notes

Koalas have a naturally high head-to-body ratio, and are therefore perfect subjects for chibi style. Their bodies are round or pear shaped with fluffy wing-shaped ears. Koalas are marsupials and the females carry their young around in a pouch. Contrary to some depictions in popular culture, koalas don't have tails and are not related to bears.

Color Palette

Koala fur varies from gray to dark brown to white albino with a tinge of pink in the ears. Colored accessories and props brighten up the palette and give the illustration a funny, surreal touch.

Fur

Mouth and cheeks **Nose**

Accessories and props **Easel**

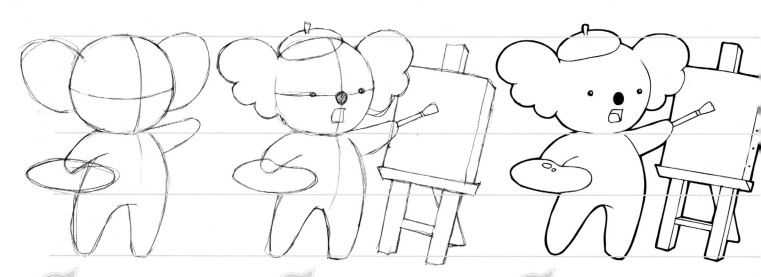

1 This body shape is a lot like a human chibi. Start with a circle and crossbar to show in which direction Pierre is looking. Then add wing-shaped ears to create the animal impression.

2 Use the crossbar guidelines to help you position the eyes, nose, and mouth. Add simple accessories and props to create an unusual yet amusing composition.

3 Always use a ruler if you're drawing objects with straight edges, especially if they feature thin parallel lines. Chibi style may be simple, but aim for correct perspective and angles whenever possible.

USING EARS TO EXPRESS EMOTION

Koala ears can be used very effectively to communicate feeling. They can be tilted up, down, or asymmetrically.

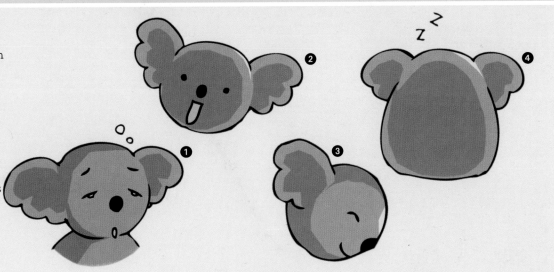

Floppy ears and half-closed eyes create the perfect sleepy expression (1). A happy face with perky ears conveys an immediate sense of gaiety (2). Practice drawing ears from the side view or various foreshortened angles (3). A koala in repose has drooping, restful ears, as viewed from behind (4).

See also

How to draw chibi animals page 40
Digital media tips page 20

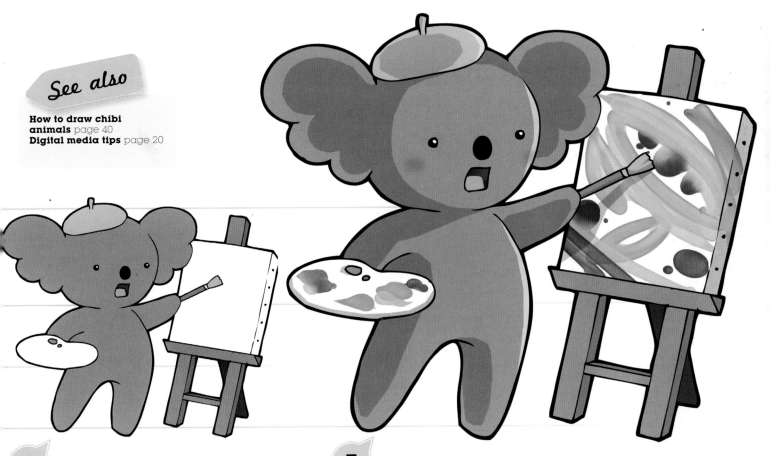

4 Fill in the colors using the Magic Wand. Yellow-green shades such as lime green, tea green, chartreuse, or olive are more flattering when used together with warm grays and browns.

5 Shade Pierre using the Polygonal Lasso and create his artwork separately using a paint-textured brush. This sets it apart from the cel-shaded surface of the illustration. Add a subtle shadow under the paintbrush to increase the realism.

KITTY
Every day is a Lucky day

Despite constantly getting into trouble during his adventures, Lucky always lands on his feet. A regular in the kitchens of many of the houses in his neighborhood, this kitty is never short of a free meal!

Style notes
Every pet has a unique personality. Try turning your own pets into characters to use in your future drawings or comic projects. Think about what your pets' favorite foods are, where they go to chill out, and even what they think of you as an owner as starting points for a story.

See also

Showing emotions page 34
How to draw and color eyes page 30

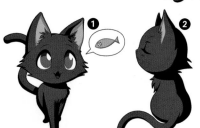

Kitty body language
In cats, ears facing forward and a question-mark-shaped tail indicate curiosity (**1**). Lucky will turn ~~her~~ *him* nose up at anything that doesn't please ~~her~~ *him* (**2**). Folded back ears show that Lucky is feeling relaxed (**3**).

1 When drawing fur, use irregular strokes to make it more realistic and alternate between big and small tufts. Vary and adjust the line widths during the inking process to create depth.

Color Palette
When coloring in black, details can often be lost. Substituting a dark bluish-gray for black allows details such as the line-art to be seen while still looking like black. There are many breeds of cat with various fur colors and patterns—look up a few for inspiration for your own kitty character.

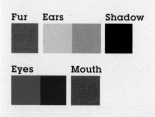

Fur	Ears	Shadow

Eyes	Mouth

2 Clean, solid outlines allow the colors to be filled in easily using the Magic Wand. Purple is a very versatile shade because it adapts well to many other colors. Here, a dark purple is used to indicate black and a lilac tone substitutes pink for Lucky's ears.

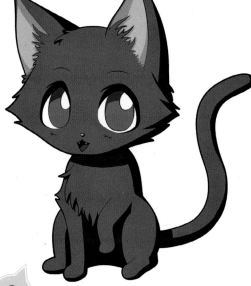

3 Shade in cel-style using a hard-edged brush. Not adding an iris to the eye makes the gaze appear glassier and less intense. This effect makes the character seem cuter and more adoring.

Style notes
To create a punk look, Dexter sports a Mohawk hairdo and collar with studs or spikes. A bone is also a mandatory accessory, which serves both as a portable snack and a prop to make him look more dangerous!

Dexter is the small spoiled dog of a rich lady, and he feels, like many dogs his size, much bigger and stronger than he actually is. A tough little rebel, he loves studded punk collars and spiky hair. But Dexter only puts up a tough outer shell to hide the fact that he's actually a soft puppy on the inside.

1 Work your outlines very crisply with varied line weight and no sketchiness. Chibis are quite small so it's important to work cleanly and show detail without overwhelming the image. Instead of round smooth lines, also experiment with an angular, chiseled style for an edgy effect.

Puppy poses
Make your character even cuter by reducing the head-to-body ratio. Simple details such as a thumping tail (**1**) or snoring (**2**) will lend a comic effect to the image.

2 Fill in the base colors using the Magic Wand tool. Notice how the bone is a light cream color instead of pure white. Plain white and black are bland to work with, so always try to have a tint of color in your neutrals.

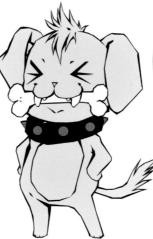

Color Palette Dexter has sandy-colored fur that contrasts well with the dark leather of his collar. An understated palette is easy to work with and visually chic.

3 Add angular shadows with the Polygonal Lasso, taking care to maintain the same tonal contrast of light and shadow throughout. If one specific color has too much or too little contrast, it will make the whole image appear inconsistent. Lastly, a few subtle highlights give the chibi a sense of volume without making him look shiny.

Skin Tummy Collar Bone Nose

Chapter Three

CHIBIS IN CONCEPT

This chapter explores the ways in which you can use chibi style in creative work. Chibis make great mascots, caricatures, or detailed illustrations. This chapter also includes an introduction on how to create characters for animation, which is useful if you're interested in making your own anime or video games.

A mascot is a character that is used to represent a group, product, event, or brand. Chibi style is often used for mascot design because it's naturally stylized and draws attention to features such as face, hair, color, and gesture. Mascots can take on any form, the most popular being humans or animals. This section shows you how to design both kinds, and create cute and memorable mascots!

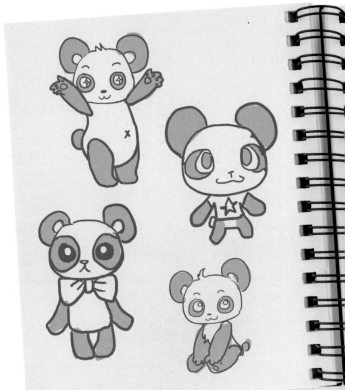

Developing designs: Toy company mascots

Fluff and Tuft are cute animal mascots for a toy company. Fluff represents the girls' product range, while Tuft looks after the boys' toys. Designed to appeal to a younger audience, they are both happy, friendly, and inviting—but Tuft does occasionally get into trouble!

1 Some of Tuft's original design sketches were combined to get his final design. Some of the desirable elements were his energetic pose, cuteness, and his cool t-shirt for some identity.

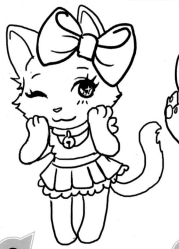

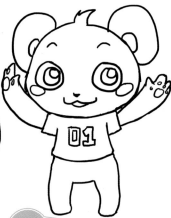

2 The final design sketch for the pair shows off their personality types. Fluff is friendly if a little bashful, and Tuft is energetic and happy-go-lucky.

3 In the final artwork, both Fluff and Tuft are colored to match their gender association. Pink is for girls, and blue is for boys. Widely held conventions like this can be useful for mascots, since they're so quick to process.

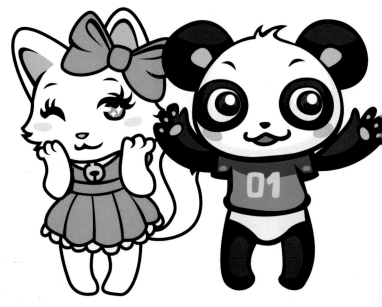

Developing designs: Video game mascot

Pastrii is a quirky dessert chef for a crazy bakery. Being the mascot for a video game, she appeals to a wider audience by being feisty and boisterous instead of being too meek and cutesy, but she still makes delectable donuts and perfect profiteroles!

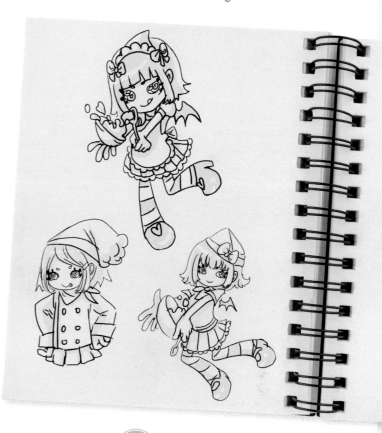

1 Pastrii started life as a cute pastry chef, with each design revision adding some personality and attitude, but keeping some stylized chef elements such as her apron, mixing bowl, and hair accessories.

2 Once the design was approved, Pastrii was scanned and colored in Adobe Illustrator, which is great for mascots and logos. Vector graphics can be reproduced on anything from small stationery to billboards without losing any quality.

3 With the outlines complete, several color schemes were tested. Pastrii's final colors influenced the game's user interface and entire look.

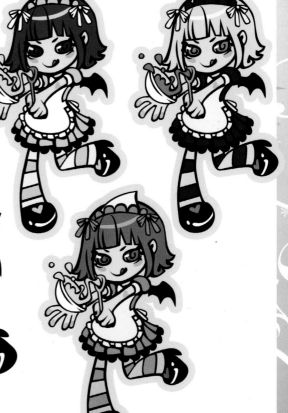

Mascot tips

Character mascots are most effective when they are immediately recognizable, which means being both simplistic and, more importantly, unique. It's also helpful to think about how the character should reflect the brand. After all, a perky penguin might not suit a paint-balling league, and a serious soldier won't suit an ice cream brand.

HOW TO DRAW CHIBI CARICATURES

Drawing a chibi caricature is really easy and lots of fun. You don't need to worry about accuracy or realistic features too much. Bringing out the personality is the aim, so they make great gifts for your friends, or victims!

wide eyes, pink hair, accessories, smile, peace sign

1 Start off with a good photo reference of the person you'd like to caricature. Make a note of all the unique features and attire that brings out their personality, such as her slight smile and peace sign gesture.

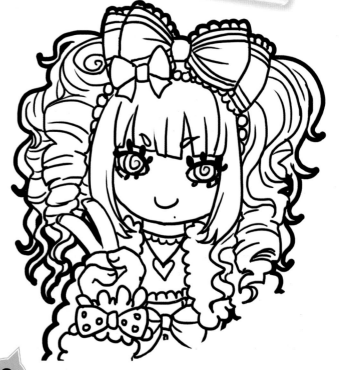

2 The girl in the reference photo has incredibly big hair and lots and lots of accessories, which are great examples of unique features. While sketching, these can be simplified and stylized. Using a pink pencil enables you to remove traces of the sketch more easily during digital retouching.

3 Ink over your final sketch while keeping an eye on your photo reference for details. Try not to be too realistic, exaggerate important elements that bring out your subject's personality, and simplify everything else! Her peace sign is slightly angled on the photograph, so you can adjust the pose on the caricature to make it much more obvious.

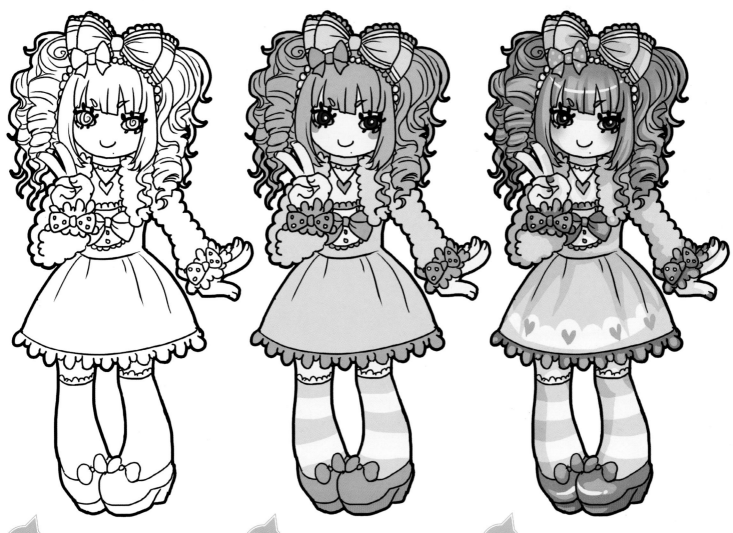

4 Remember, the pose and outfit help to convey the identity too. Here, her feet point inward for extra cuteness and her outstretched arm balances the overall composition while adding a touch of daintiness. Even if the rest of the body isn't visible on the photo, you already have enough visual information to extend the portrait.

5 Color is hugely important in conveying personality, so make sure you choose a color scheme that matches your subject. Our girl clearly loves being girly and the color pink, so try saturating the shade to exaggerate this trait. To keep the picture from being too flat, add a cooler purple as an accent color.

6 After the line art is filled, touch up with some shading and highlights and add details (like nail polish and the dress pattern shown here) to finish the piece. The colors don't need to match identically with the reference photo, as long as they capture the spirit of the subject.

Sourcing reference photos

Social networking websites make it easy find a lot of reference photos of your friends. If you want to surprise them with a chibi portrait, simply log on and find some pictures that best show the elements below. Carefully study how these elements can differ from person to person and draw them in manga style onto your chibi.

- Eye shape and color (1)
- Eyebrow shape
- Mouth shape when smiling or mouth shape when closed, depending on what sort of personality your friend has (2)
- Hairstyle and color (3)
- Skin tone
- Favorite or most memorable outfits

A real hallmark of Japanese comics is the use of chibi style during a comical moment in the story. The characters usually have conventional proportions, but they become chibis selectively, when necessary. It sometimes causes consternation to the uninitiated, but once you read a few manga series, particularly those aimed at teenagers or younger audiences, it feels absolutely appropriate. Sometimes the scene is so silly, nothing but chibis will do!

When to switch to chibi

The series may be an action adventure or a drama, but there are times when you need to enhance a light-hearted moment during the story. Think of it as comic relief to alter the pace and tension. Chibis can also be used to show fantasy scenarios, worst-case scenarios, or slapstick incidents.

Visual grammar

A manga artist switches to chibi style to showcase the situation. As such, the emotions of the characters are usually running pretty high, be it someone in love, someone doing something really stupid and being embarrassed about it, or someone who is furious. It is very important to get the expressions right.

Extreme emotions often require visual grammar. This is a form of comic symbolism to focus or enhance a character's state of mind.

Note that visual grammar isn't new, nor is it confined to Japanese manga. A well-known Western example is a light bulb appearing beside someone's head when they have a bright idea. Some symbols are universal now, like the heart shape to indicate that someone is in love.

Degree of chibi

Not all chibis are created equal. The sillier the situation, the squishier and simpler they can get. Drawing chibis with low head-to-body ratios focuses the viewer's full attention to the facial expression (see page 26).

Chibis in yonkoma comics

The Japanese equivalent of a typical comic strip you might see in the newspapers is called the yonkoma, or 4-koma comic, which contains four panels or cells. These are drawn vertically. Like their Western counterparts, they are used almost exclusively for short gags, but unlike the Western versions, there are a lot more "omake," which are out-takes or extras. A normal manga graphic novel may have yonkoma strips at the back as cute omake, showing the main characters acting out of character, the creator's trials during the making of the book, or commentary on current affairs or hobbies. As a yonkoma is a running gag, chibis are standard fare.

Using chibis in promotional artwork

Making a manga isn't just about drawing comic pages. You have to make the whole package, so this includes covers, splash illustrations, and advertisements and extras. Chibis are not usually used on the front covers unless the characters are meant to look like this all the time (which is rare). Use them on the back cover, or as merchandise.

Using visual grammar

Even on a single page, a character can go through multiple states of mind. In this example, the female character regrets leaving a bad impression on the new boy in class. Note the sparkles for love and happiness, and the darkness and gathering spirits for impending doom.

Page analysis

Here is a classic example of how chibis can be used in a manga comic. This page is from a manga adaptation of a traditional fairy tale with adult characters and a dramatic storyline. Using chibis as a storytelling device breaks up the pace of the story and makes it more entertaining for the reader.

Opening scene

Manga stories should begin with an establishing shot to show the reader where the action is taking place. Showing the scene without panel borders enhances the sense of space. Backgrounds can be trickier and less fun to draw than characters, but a beautifully rendered setting makes a big impact on your comic.

Introducing characters

Before bringing in chibis, it's important to show how the characters should look in their default state. This way, the reader will know whether the chibis are there for comic relief or whether the entire comic is in chibi style.

Here come the chibis

Chibi style is used here to reveal a lot more about each prince's personality, making it an important narrative tool in addition to comic relief. Notice how the visual consistency is maintained by showing them in the same positions so the pacing effectively "jumps" from one panel to the next.

Pin-up illustrations are polished pieces of artwork that showcase your character designs and drawing skills. You can have a lot of fun experimenting with composition, backgrounds, color, and lighting, and the end result will be most rewarding to look at. A little self-discipline is also required to see the task through, since you may have to work on the same image for long periods of time.

Less is more

It can be tempting to keep adding embellishments to a pin-up illustration in the belief that more detail will enhance the final result. However, an overworked image can often appear more rushed and thrown together than a drawing done in less time. Try to avoid superficial graphic effects such as lines, shapes, shadows, lens flares, and overuse of symbol brushes. These only draw people's attention away from the real artwork that you spent so long creating. Manga covers often favor a single-colored gradient or patterned background because it places emphasis on the character and text.

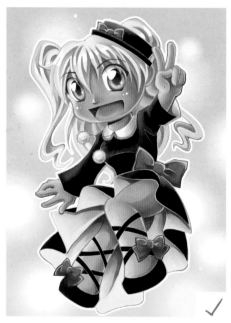

Correct
This character fills up most of the page, so the background should act as a simple backdrop. Matching colors and soft textures creates enough visual interest without becoming intrusive.

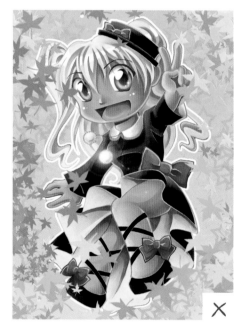

Avoid
The same space has been overworked with "empty detail." Even though there's a lot of imagery, it looks obviously duplicated, thus conveying haste. The image itself also doesn't look as impressive.

Drawing tip

When working digitally, custom brushes are a great way to save time and provide your illustration with instant background effects such as glitter, sparkle, stars, or snow (shown left and right). Search online for the program you have plus "free brushes" or try free resources, such as www. obsidiandawn.com. Use these pattern brushes sparingly and don't cover up large areas of your illustration with images that look like obvious duplicates.

Common background effects

The backgrounds below can be painted quickly with only a few changes of color. They may be useful if your foreground characters are very complex.

Sea

1 Fill the sky with a gradient of gray-blue and the water with a green-blue. Blend the edges together where the water and sand meet.

2 Define the water's edge using a thin white line. Keep this shape slightly irregular to mimic gentle waves. Use the Brush Tool to paint in a few clouds (see below).

3 Add reflections using oval circles of varying transparencies and a few sparkles.

Sky

1 Use a gray-blue to purple-blue gradient as the base. If you're using traditional media, leave out the areas you want for clouds at this stage.

2 Paint in rough white clouds with a soft-edged brush, but not an airbrush, since you should still have some defined edges.

3 The Liquify filter in Photoshop is an easy way to drag your clouds into realistic-looking puffs and swirls.

Fantasy

1 Unusual colors can give your image a dreamy, surreal atmosphere. Use a pink gradient for the sky and paint in lilac clouds.

2 Create a moon by drawing a white circle, then selecting and deleting a smaller circle inside it. Add some simple shading to the clouds.

3 Adding layers of stars in different shapes and transparencies completes the magical effect.

Creating a pin-up illustration

This page shows you the typical workflow of a pin-up illustration involving thumbnails, composition, backgrounds, inking, and coloring. Consider whether you need to leave space for a title, logo, or text. This image was created digitally in Photoshop but the overall process is the same for traditional media.

1 Before you start a complex image, sketch out some thumbnails to plan where all the elements should go. Try to have an idea what sort of background you want and make sure there's enough space available. A large background feature, such as the maypole here, or a building or mountain, should be planned into the composition from the beginning.

2 Overlapping elements give the scene more depth, so think about which ones can go in the foreground and which in the background. If your background is more realistic, make sure everything is drawn with the correct perspective.

3 The coloring process may take some time, especially if your image consists of many characters. Consistency is key, so try to color in all the chibis using the same level of detail, light source, and with complementary color palettes.

Flowers to go on top layer

Animals overlap the background

Overlap so animals are in front of brown bear

4 Many artists may find the background less enjoyable to color in, and by this stage you may be longing to complete the image. But resist the urge to rush the final step, since a beautiful background can have a big impact on the final piece.

Drawing tip
Choosing a setting and context for your pin-up makes it easier to come up with visual elements for the background. The above image is set on midsummer night in Sweden, which provided a starting point for researching the correct scenery, flowers, and decorations.

ANIMATION: AN INTRODUCTION

This section introduces two different types of animation. The first method is known as "cut-out" animation and requires you to create a character in segments. These individual elements are reassembled and animated, almost like a puppet. The second method is "keyframe" animation where every frame of movement is drawn by hand (see pages 118–119). Keyframe animation is more time-consuming but creates a smoother range of movement.

Creating a chibi for cut-out animation

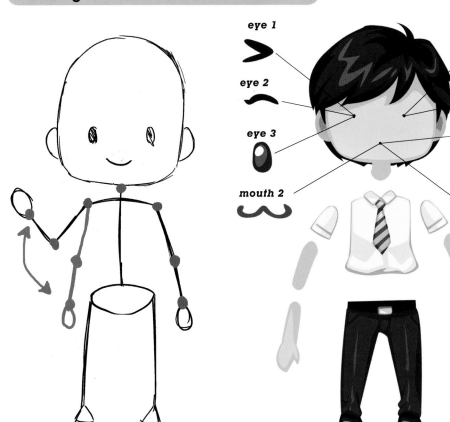

eye 1
eye 2
eye 3
mouth 2
eye 1
eye 2
mouth 1
mouth 3

1 Daryl the star student was created in Adobe Illustrator. Illustrator works with vector graphics, making it compatible with animation programs such as Adobe Flash. Use quick skeleton drawings to map out joints where movement will occur. This helps you to break the body down into segments that can be animated.

2 Prepare your artwork, separating sections of the body that need to be used for animation. Create separate artwork for any changes in the character that cannot be achieved through position and size changes, such as the eyes and mouth, for different expressions.

Animation tip
Keeping the artwork simple will ease your animation process. Remember, the more detail your character has, the more work it is for you, since you may have to redraw this over and over again in different poses and angles. Getting to grips with animation can be a fussy process, but with diligence and patience, you will be able to bring your chibi characters to life.

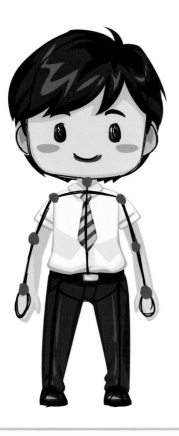

3 Assemble the different parts to form the initial pose of your character. There are many kinds of standing poses that can give your characters different looks. Here, Daryl is standing in a neutral stance. During animation, you can create whole new poses by swiveling the limbs into different positions.

Hello there
These poses were created from the same elements as the initial pose. Daryl waves at a friend and gets jiggy to his favorite music!

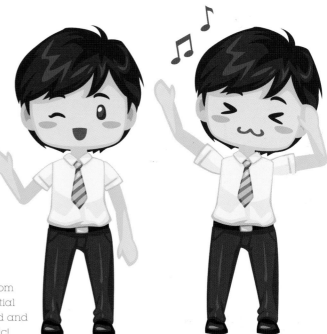

Animating your chibi
Now it's time to import Daryl's body into Adobe Flash to be animated.

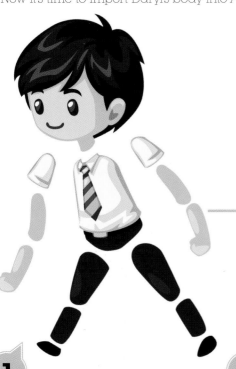
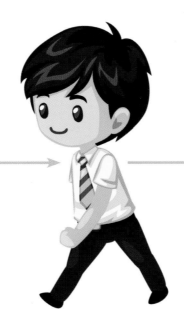
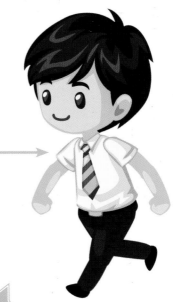

1 You can simply copy an element from Illustrator, and paste into Flash. Then right click on it and choose "Convert to Symbol." Turning an object into a symbol lets you move it about and apply different animation effects. Remember that every element (face, features, the hand, lower arm, upper arm, etc.) should be saved as separate symbols.

2 On your timeline at the top, create two keyframes to determine the duration of one pose. Click on the first keyframe and place your symbol in its starting position. Click on the second keyframe and move or swivel your symbol to its end position. Now right click in the timeline between the two keyframes and choose "Apply Classic Tween." The symbol should move from its initial position to the new one.

3 Using tweening, you can animate all the elements of a character so the arms and legs move in sync. Try drawing the character from the side to create a walking cycle. If this is your early attempt at animation, much like drawing the chibis themselves, it is wiser to start with smaller, simpler sequences (such as hand waving, changing of expressions, etc.) to familiarize yourself with new techniques and software.

Drawing a chibi for keyframe animation

Before animating, it's best practice to create a "turn-around" or "model sheet" to help you keep track of the character's proportions and design elements. A turn-around is your point of reference for the character, so along with the design from different angles it can also include your palette, alternative outfits, typical facial expressions, or anything at all that will help you (or other animators on a project) keep consistent whenever putting the character into a scene.

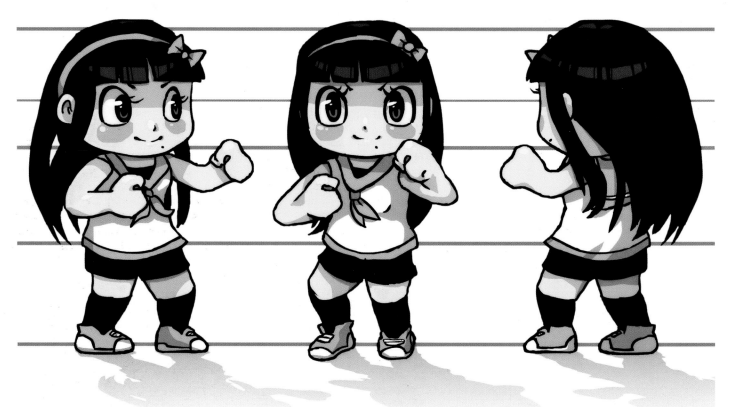

Running keyframes

A run cycle is a short animation that can be looped so that the character can keep running without drawing every stride. Run cycles typically have eight basic keyframes:

- **Contact:** Where the front foot touches the floor.
- **Land:** Where the fall is broken.
- **Propel:** Where the character pushes forward.
- **High:** The highest point, where no foot is touching the ground.

And then the same four poses, but with the feet/arms reversed. Pictured at right is a simple run animation, but by changing the look of the keyframes, you can change the personality of the run. For example, a determined character may lean forward, or a comical character might lean back. You can experiment with any other element of the run to make it suitable for any character.

Right leg

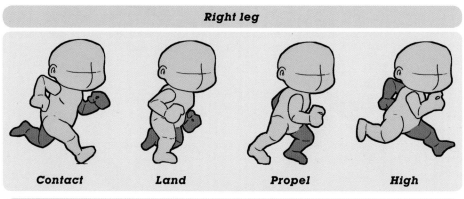

Contact Land Propel High

Left leg

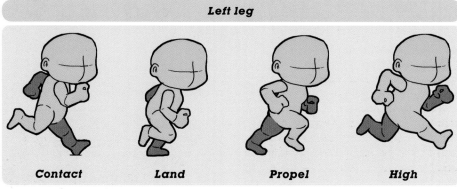

Contact Land Propel High

Animating the run cycle

In keyframe animation, it's best to start with the most important stances within your animation, like the running keyframes. The first set of keyframes can be quite sketchy (sometimes called "rough keys" or "pencils"), so you can spot errors or adjust anything easily. Once you're happy with them, you can make a cleaned up (or "inked") set of keyframes by tracing over the sketchy layer. Depending on how smooth you want your animation, you can also draw in additional frames between the completed keyframes (known as "in-betweens"). While this tutorial has been created with Adobe Flash CS4, earlier and later versions of Flash will also work fine, as well as other similar animation software. If you have any trouble finding the tools in Flash, try changing the workspace to "animator" mode.

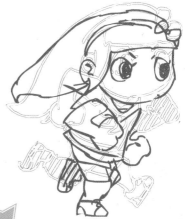

1 With a completed turn-around, sketch out your rough keys. Keep your run cycle in a new Graphic Symbol (ctrl-F8) and add blank keyframes into its timeline (Insert > Time Line > Keyframe) until you have eight frames. Draw a slightly different pose into each frame using the Brush tool. Shading the far limbs helps you spot errors while testing the animation.

2 When drawing the other keyframes, use onion-skinning tools (in the Timeline window in Flash) to see outlines of near-by frames, and remember to preview the animation often. If anything's wrong, it's easy to adjust while in the sketchy stage. For smoother animation, add extra frames between the keys, and use the onion-skin to help you draw the in-betweens.

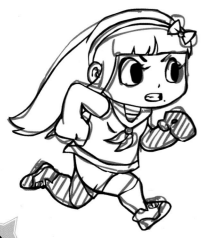

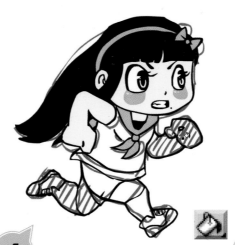

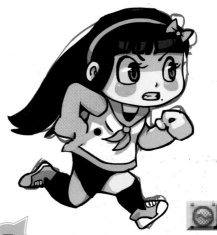

3 Once the roughs are animating well, you can begin to clean them up. Create a new layer above your rough sketch layer and add some blank keyframes. Use the roughs as a guide while you neatly redraw the outlines.

4 Before using any color, add the colors from your turn-around into the "Swatches" window, if using Flash. After the final keys are outlined, use the Paint Bucket tool to fill in the base colors.

5 A trick to shading in Flash is to set your Brush Tool's Brush Mode to "Paint Selection" so you can shade to the edge of your selected shape without spilling over the outlines. Once finished with all the frames, remove the sketch layer.

6 Create a background for the character to run over (in a separate Graphic Symbol), and drop your character on top in the main Timeline. You can optionally add some extra detail such as dust clouds, then Marby is finally ready to chase down that ice-cream van!

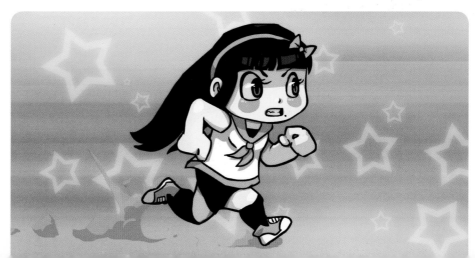

Chapter Four

PROMOTING YOUR WORK

Find out about the best ways to share work online, create a virtual or printed portfolio, and how to promote yourself as an artist for hire. You may even end up turning this hobby into a career!

PRESENTING YOUR WORK

Drawing is a hobby that brings you two big rewards: the introverted experience of creating art and the extroverted process of displaying art. Your skills may stagnate if you don't feel motivated to practice, so it is important to find an outlet for your work and connect with like-minded artists. The Internet has made it convenient to display your artwork, receive feedback, and interact with others. You can also put together a portfolio and take it to manga-related events for review and feedback. Here are some guidelines to make the most out of your artistic presence.

Online galleries
There are many free image-hosting websites that allow you to upload and maintain a portfolio of work. Most also have a social networking element so you will be able to interact with other artists and take part in community projects.
- **Pros:** No programming knowledge needed, easy to maintain, will attract more feedback from the existing community. This is also a great way to familiarize yourself with the manga scene and become aware of events or competitions.
- **Cons:** Lack of individuality and constructive criticism. Big sites may feel overwhelming and anonymous, with a negative effect of de-motivating you from drawing. Rarely frequented by companies seeking professional work.

Online forums
Discussion forums are smaller and more intimate places to display work. They are not intended as a portfolio but more a way of gaining immediate feedback from a selected group of people.
- **Pros:** Easy to use and more personal. Feedback is usually more constructive, especially if there are experienced or professional artists around. Better team spirit and motivation.
- **Cons:** Not intended as a permanent display of work and may require registration to view images and threads. Time sensitive, so any entries you post will gradually fade downward after a few days.

Art blog
Many artists like to keep a "sketchblog" where they post updates of work in progress or final pieces. This is often done as an addition to a regular portfolio website.
- **Pros:** Free to use, easy to update, and can be personalized to reflect your style or web design. Fun if you have existing friends using the same blogging platform.
- **Cons:** Will attract fewer visitors and therefore feedback. Difficult to get the social element started unless you know many existing artists with the same type of blog.

Website
A proper .com website is still the most professional and lasting way to create a web presence. You have full control over the content, but it also comes with more work and responsibilities.
- **Pros:** Demonstrates professionalism and easily located by potential clients or publishers. The visual look and user experience can be personalized to represent you as an artist and "sell" your art to the public.

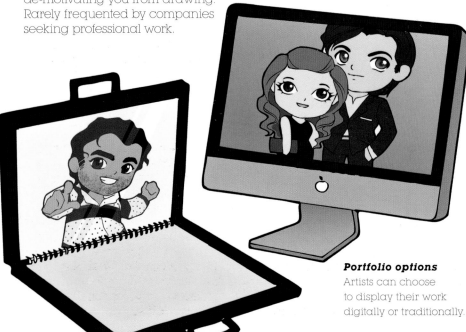

Portfolio options
Artists can choose to display their work digitally or traditionally.

Tip
When saving in JPG you will get the option to save at different quality levels. Always set it between 8–12 (high to maximum). Any lower and your image will start getting "artifacts," which are blurry areas of compression that spoil the image.

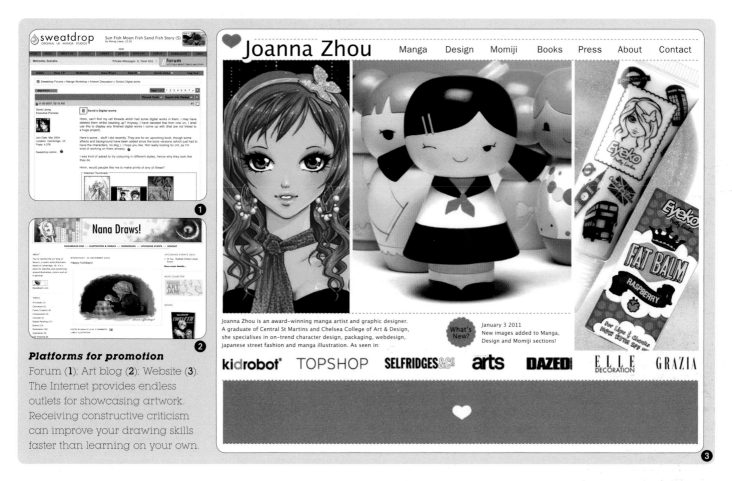

Platforms for promotion
Forum (**1**); Art blog (**2**); Website (**3**). The Internet provides endless outlets for showcasing artwork. Receiving constructive criticism can improve your drawing skills faster than learning on your own.

■ **Cons:** Requires some technical knowledge to create and financial investment for hosting and domain charges. Can backfire as a poorly designed website may create an unnecessarily negative impression of the content.

Printed portfolio
Most artists choose to display their work digitally, but printed portfolios are still important for interviews or higher education art courses. They also come in handy at events, meetings, or interviews where there is no easy Internet access.

■ **Pros:** A classic and professional way of presenting work. Good for gaining real life contact with industry people and a starting point for discussion and feedback.
■ **Cons:** Requires careful editing to ensure that the selection of work is the best representation of your skills (always quality over quantity). Costs money to print and mount, can be cumbersome to carry.

Intellectual property
When you're drawing for yourself, there are no limits to how or what you draw. Some artists like to copy existing images as a way to learn hand-eye coordination and others take shortcuts by referencing poses. However, as soon you display your work publicly, you are implying that you take credit for every part of it. This would be a problem if you have used another image as a reference, so check the following to avoid possible copyright infringement:

Tracing
Traced images must never be given out as your own. For starters, traced images are very easy to spot and expose because they look identical to the original. Tracing is only acceptable if you are tracing your own drawings in order to outline or edit them, but tracing other people's work has no learning value and should be always avoided.

Referencing
This is when you have drawn your image by looking at an existing picture, but changed some details, such as clothing and colors, so it feels like an original piece. It's much easier to copy an image than draw from scratch, so try to stay away from referencing because it creates a misleading profile of your true artistic skills.

Fanart
If you created the composition from scratch, fanart can be a good demonstration of your drawing skills. However, since fanart relies on existing character and costume design, there is still a degree of "borrowing" ideas. This is fine for nonprofit projects but try to avoid including fanart in professional portfolios, and definitely do not use fanart for paid or published commissions.

How to adjust Image Size using Photoshop
1. Open your image and go to Image > Image Size.
2. You can manually input the resolution and/or dimension for your image. Remember that scaling an image down is always better because it increases the sharpness and detail. Scaling up will result in blurriness and pixelation.

RESOLUTION

Whether you show your work online or in print, a good presentation will always create a better first impression. Final pieces should generally be saved in two versions: one at web resolution (72 dpi) for uploading online and one at high resolution for print (300 dpi–600 dpi). Web images tend to be much smaller to reduce loading time, and the key is to find a right balance between compression and image quality.

72 dpi

150 dpi

300 dpi

3. Keep your default resolution at a minimum of 300 dpi. This way, you always work at print size and avoid having to scale a small image upward.

Common file formats and sizes
The table below shows measurements that you can expect to see when saving a full-color image. If your file ends up with large discrepancies, check your settings to make sure it's being saved correctly. Generally, images for the web should be less than 1 MB, and images for print can be anywhere between 2 and 50 MB.

Preventing digital theft
Whenever you put your image online, there is always the risk that someone may steal it. Generally, the benefits of having people see your work and getting constructive feedback greatly outweigh the tiny risk of plagiarism. But if you are bothered by the thought of someone saving your art, you can put a watermark on your image, place a transparent GIF over the entire top, or use code to disable right clicking.

Printing tips
If you are preparing a printed portfolio, using photo quality paper is vital in bringing out the image quality. Make sure the corresponding paper is also selected in your printing options screen so the printer knows to print using more ink. Printing on regular, thin paper is not advisable because the result will be bland and flimsy, with washed-out colors. Photo paper and printer cartridges don't always come cheap, so you may find it more convenient to burn all your work onto a CD and have it printed at a professional copy shop.

Mounting tips
Images with a printer-induced white border appear unprofessional and should be trimmed off whenever possible. Use a guillotine at school or university if you can, or trim it carefully with a craft knife, metal ruler, and cutting mat. Scissors are a big no-no because they make the edges look uneven. Mount your borderless image carefully onto a piece of black or white card using spray mount or double-sided tape. Avoid thick glue or anything that might make the paper buckle.

File format	Size	Resolution (dpi)	Memory space
JPG	1000 x 600 pixels	72	300 kb (< 1 MB)
PNG	1000 x 600 pixels	72	900 kb (< 1 MB)
JPG	Letter size	300	2 MB
TIF (with LZW compression)	Letter size	300	7 MB
PSD	Letter size	300	120 MB

GETTING PUBLISHED

There might come a day when you realize that manga means more to you than just a hobby. It's a niche market and you will not become rich, but getting paid to do what you love is a truly fulfilling career experience. Creative industries differ, so there isn't one rule to guarantee success— just keep trying and stay flexible. If one route isn't working, try learning a new style or media to expand your skills. Drawing professionally isn't the same as drawing for leisure, so review the notes below to see if it may be the career for you.

Is my art good enough?
You need to be objective and decide whether your skill level is comparable to existing examples of published art. Be aware that friends and family will always praise your work, but a publisher or editor may look at different criteria.

Can I take criticism?
Paid work has a larger exposure range so you will need to be open to feedback from your client, and from the public. You cannot let negative criticism discourage you.

Am I precious with my work?
When working professionally, your art becomes a commodity so you cannot feel emotionally attached or reluctant to discard or change drawings that you may have worked very hard on.

Am I willing to sacrifice my personal life?
Professionalism is the ability to put your work ahead of everything else. Can you see yourself missing out on special events to finish a commission or sitting down to draw when you're feeling uninspired or even ill?

Socializing
"Networking" makes this activity sound dull and corporate, when in reality, it's simply about getting to know new people. Building a solid network of friends who all work in the same industry makes it far more likely that you'll hear about or be recommended for job opportunities.

Enter competitions
This is an excellent way to gain experience because the process teaches you real-life skills such as self-discipline, self-direction, and dealing with disappointment. It also encourages you to participate in group discussions and community spirit that will strengthen your social ties with colleagues.

Take the initiative
Contrary to popular belief, simply becoming an "amazing artist" does not guarantee commissions flooding through your inbox. You need to promote your own work to publishers or magazines and show them that you're a reliable person to work with. If a client describes a project to you, send through some visual proposals without expecting to get paid for it. It's the extra initiative that will impress.

Professionalism
There are basic work etiquette rules for leaving a good impression. When writing work emails, always use correct greetings, punctuation, grammar, and spelling. Try to avoid abbreviations and emoticons. Reply to any work-related email within 24–36 hours, give concrete details/dates and follow those through.

Paperwork
Once you start receiving serious commissions, you should register as self-employed with your tax office and also file your taxes every year.

(In most countries you won't need to pay tax until you're earning over a specific amount so do some research on that too.) Learn how to write invoices and keep a record of them. This can be a hassle at first, but is a vital part of being a freelancer.

Pricing
"How much do you charge?" is often a dreaded question for the starting artist. This will depend on your experience, the size of the project, the size of the client, and the exposure involved. If in doubt, "What is your budget?" is a fair response. Most reputable clients will have a budget set aside for artists. Otherwise, calculate how long it will take you to complete the task and set an hourly rate. What sounds like a reasonable fee may actually be a lot less if you factor in how long it takes to complete the task, so don't let yourself get pulled into working under the legal minimum wage per hour.

Money
Drawing professionally is not a highly paid job, so you need to have some perspective over your preferred lifestyle or living costs before throwing yourself into this career. Do you have a regular day job, savings, or some sort of financial fallback during phases when you don't get commissions? Some artists manage to supplement their income by giving workshops or lessons.

Resources

*All foreign websites listed have English
versions and ship to the United States.*

Software and hardware
- Photoshop, Illustrator, Flash:
 www.adobe.com
- Manga Studio:
 manga.smithmicro.com
- OpenCanvas:
 www.portalgraphics.net/en

- Painter: www.corel.com
- Artrage: www.artrage.com
- GIMP: www.gimp.org
- Graphics tablet: www.wacom.com
- Mac equipment: www.apple.com

Traditional art supplies
- Letraset: www.letraset.com
- Copic: www.copicmarker.com
- Deleter: www.deleter.com
- Dinkybox: www.dinkybox.co.uk

Fonts, brushes, and stock images
- DaFont: www.dafont.com
- Blambot: www.blambot.com
- Fontspace: www.fontspace.com
- Photoshop & GIMP Brushes:
 www.obsidiandawn.com
- Stock Photos: www.sxc.hu

Online art galleries
- Deviantart: www.deviantart.com
- ImagineFX: www.imaginefx.com

■ **Animexx:** animexx-en.onlinewelten.com
■ **Society 6:** www.society6.com
■ **CG Society:** www.cgsociety.org
■ **Sheezyart:** www.sheezyart.com

Blog and website hosting
■ **Blogger:** www.blogger.com
■ **Livejournal:** www.livejournal.com
■ **Rydia:** www.rydia.net

Manga publishers
■ **Tokyopop:** www.tokyopop.com
■ **Viz:** www.viz.com
■ **Yen Press:** www.yenpress.com
■ **Seven Seas:** www.gomanga.com
■ **Self Made Hero:** www.selfmadehero.com
■ **Slave Labor Graphics:** www.slgcomic.com

Webcomics
■ **DrunkDuck:** www.drunkduck.com
■ **Bento Comics:** www.bentocomics.com
■ **Smack Jeeves:** www.smackjeeves.com

Manga studios
■ **Sweatdrop Studios:** www.sweatdrop.com
■ **Yokaj Studios:** www.yokajstudio.com

Author credits

A big thanks to all the artists who contributed their time and art to this project, the editors at Quarto for putting everything together so wonderfully, my friends who have been a great source of inspiration, and my parents for their constant support.

Faye & Fehed, Nana, Sonia, Chloe, John, Dock, Viviane, Nina, Rik & Marby, Stefan, Noura, Jazzy, Ruth, Slick, Feli, Peter & Valerie.

Thanks to all :D

Image credits

- **8** ©Momiji www.lovemomiji.com
- **9** ©Telling Tales by Sweatdrop Studios www.sweatdrop.com
- **9** ©The Three Feathers (from *Telling Tales*) by Faye Yong, Fehed Said, Nana Li, Brothers Grimm
- **35** ©Faye Yong
- **60–63** Gothic Lolita and sweet Lolita "style notes" model—Tania Tanzil
- **111** ©The Three Feathers by Faye Yong, Fehed Said, Nana Li, Brothers Grimm
- **110** ©Once Upon A Time, Sonia Leong www.fyredrake.net
- **86–87** Origami Pattern from http://maplerose-stock.deviantart.com
- **112** Brushes from www.obsidiandawn.com
- **106–107** Crazy Bakery ©2010 RuneStone Games
- **123** Forum Screenshot—Sweatdrop Studios www.sweatdrop.com; Blog Screenshot—Nana Li http://nanarealm.blogspot.com; Website Screenshot—Joanna Zhou www.chocolatepixels.com (images ©Momiji www.lovemomiji.com and ©Eyeko www.eyeko.com)

Contributors

- **9, 35, 48–49, 59, 70, 80–81, 86–87, 116–117** Faye Yong, www.fayeyong.com
- **53, 72–73, 78–79, 84** Nana Li, www.nanarealm.com
- **82–83** Viviane, www.viviane.ch
- **90–91, 103** Nina Werner, www.ninesque.com
- **68–69, 110** Sonia Leong, www.fyredrake.net
- **94–95, 102** Chloe Citrine, wyldflowa.deviantart.com
- **85** Hayden Scott Baron, www.deadpanda.com
- **106–107, 108–109, 118–119** Jacqueline Marby Kwong, www.rockinroyale.com and Rik Nicol

Publisher credits

Quarto would like to thank the following for supplying images for inclusion in this book:

- **21** Copyright © 2011 Adobe Systems Incorporated. All rights reserved, Copyright © 2011 Corel Corporation. All rights reserved, Painting Software openCanvas. ©2010 portalgraphics.net, Copyright © 2011 Smith Micro Software, Inc. All Rights Reserved

All step-by-step and other images are the copyright of Quarto Publishing plc. While every effort has been made to credit contributors, Quarto would like to apologize should there have been any omissions or errors—and would be pleased to make the appropriate correction for future editions of the book.